NEW YORK COMES BACK

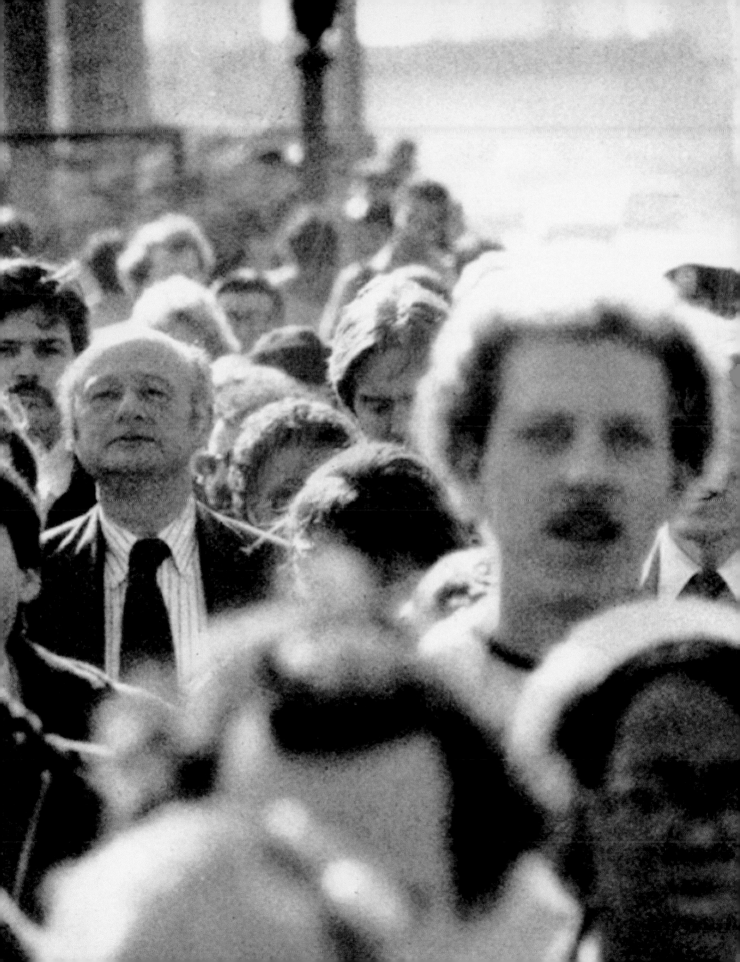

NEW YORK
THE MAYORALTY

EDITED BY MICHAEL GOODWIN
COMES BACK
OF EDWARD I. KOCH

PHOTOGRAPHS FROM THE ARCHIVES OF THE *DAILY NEWS*

In association with the
Museum of the City of New York

 pH **powerHouse Books New York, NY**

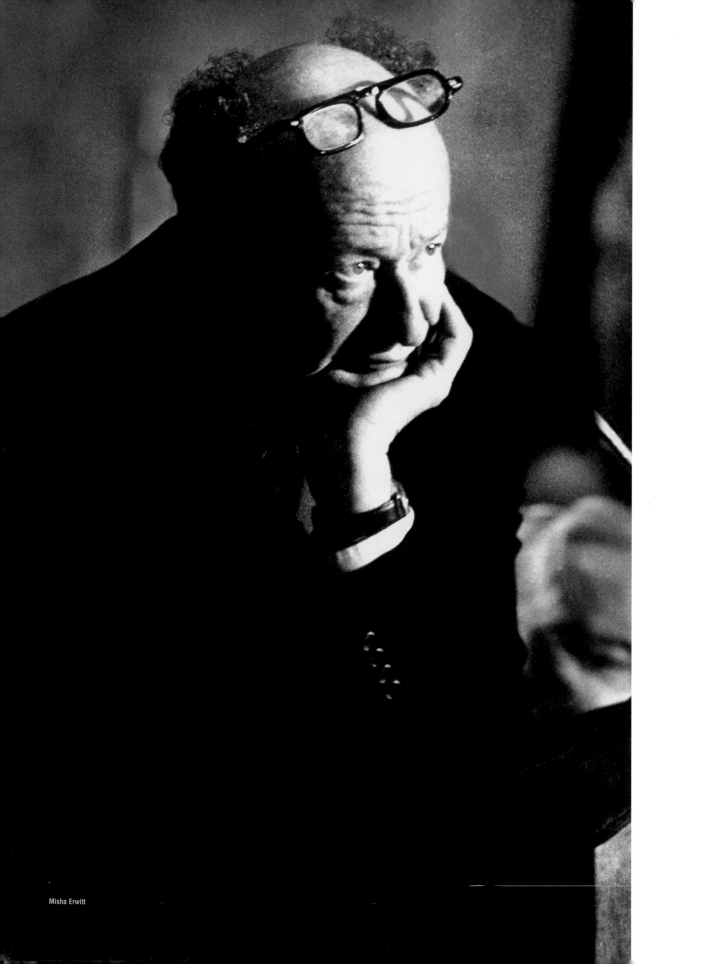
Misha Erwitt

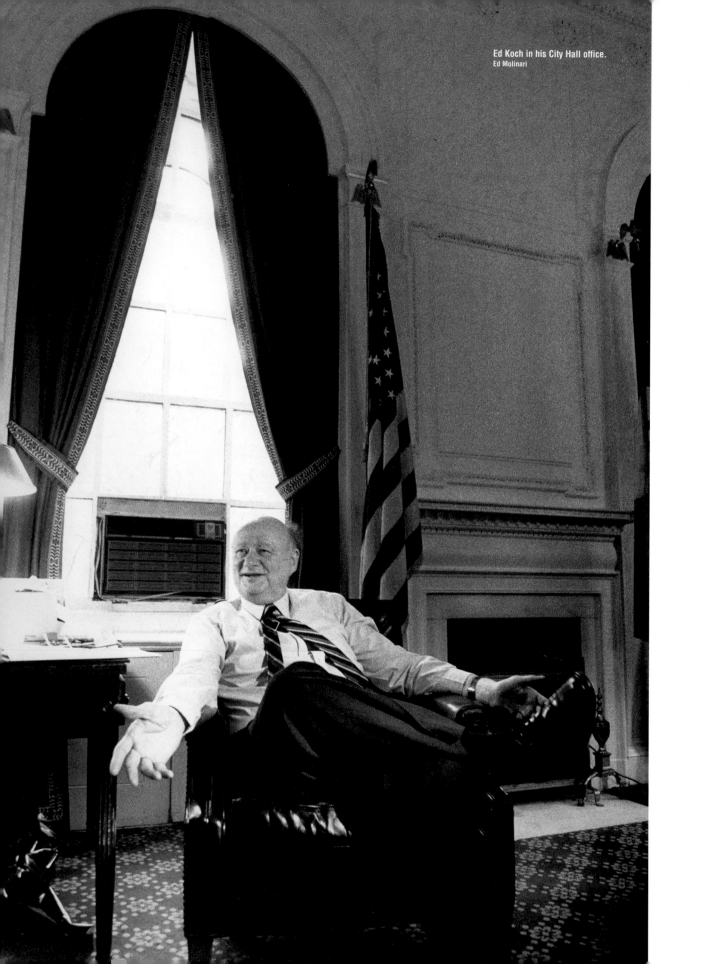

Ed Koch in his City Hall office.
Ed Molinari

SPECIAL THANKS

New York Comes Back: The Mayoralty of Edward I. Koch is published in conjunction with an exhibition of the same name, presented at the Museum of the City of New York from October 20, 2005 to March 26, 2006.

The Museum of the City of New York is particularly grateful to Diane M. Coffey for organizing support for both the exhibition and this book.

The museum is also grateful to the funders, who are acknowledged below, for making this project possible.

Benefactors
Bloomberg
The Horace W. Goldsmith Foundation

Patrons
Forest City Ratner Companies
May and Samuel Rudin Family Foundation
Verizon Foundation

Sponsors
Shelley Fox Aarons and Philip Aarons
Bryan Cave LLP
Con Edison

Fellows
James R. Brigham Jr.
James F. Capalino
Kathryn and Kenneth Conboy
Donald and Barbara Zucker Foundation
Nancy and Bob Downey
Kathe and John Dyson
Patrick F.X. Mulhearn
Real Estate Board of New York

Associates
Connelly and McLaughlin
Grenadier Realty Corporation
Mary and Frank J. Macchiarola
Luis Miranda
Peter J. Solomon Company
Howard J. Rubenstein
Joseph Spinnato

Friends
Josephine and Stanley Brezenoff
Daily News
Gordon J. Davis
Paul Dickstein
Nathalie and Robert Esnard
Henry J. Stern and Robert F. Wagner Jr. Fund
Nathan Leventhal
Joann and John B. LoCicero
Peter A. Piscitelli
Frederick Schaffer
Elizabeth and Herbert Sturz

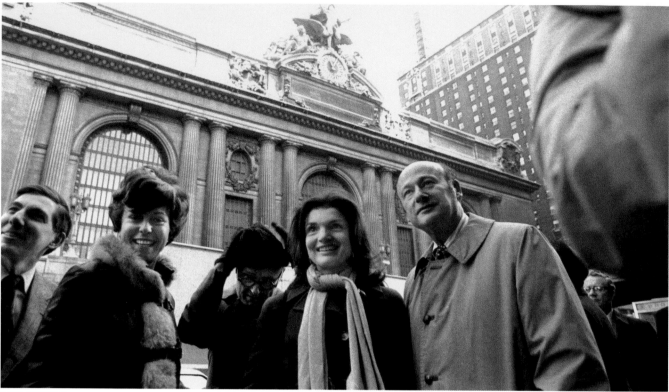

GOOD COMPANY
Koch, then in Congress, joins Bess Myerson, architect Philip Johnson, and Jacqueline Onassis in a 1975 rally to save Grand Central Terminal.
Mel Finkelstein

FOREWORD
BY SUSAN HENSHAW JONES

Edward I. Koch redefined the modern mayoralty. He was funny, aggravating, provocative, practical, brutally honest, intrepid, and in your face—in short, everything that was New York. Indeed, Mayor Koch was a crucial part of what defined this city in the late 20th century. The Museum of the City of New York, as New York's official museum, is proud to present this book and the exhibition that it accompanies exploring Koch as mayor and the pivotal decade of the 1980s.

My own early career began in city government, in the Lindsay administration, and my young adulthood was spent in the years that eventually gave rise to the fiscal crisis that confronted Mayor Koch when he took office in the late 1970s. But, in a city defined by contradiction, my experience of this historic period in New York was both dramatic and mundane. Even as the city threatened to unravel financially, everyday life generally went on pretty much as normal. We went to work, we rode the subways; we went to the park, to the theater, for walks; children went to school and played in the playgrounds. Despite the grim statistics of crime, debt, and a declining tax base, we did not live every minute of our lives warped by fear, and most of us never doubted that the city had a viable and vibrant urban future.

Ed Koch certainly never doubted it. The astonishing turnaround of New York's fortunes that began during his tenure as mayor is arguably one of the greatest success stories in the history of cities. At a time when pundits were warning that urban life itself was endangered, when many cities' embattled cores were emptying, when business and industry were moving to suburbs or overseas, Koch evinced a confidence in

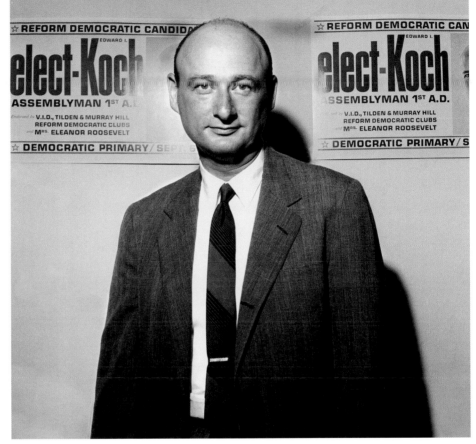

YOUNG CANDIDATE
Koch ran for the assembly from Greenwich Village in 1962 against incumbent Democrat William Passannante. He lost, called politics "a filthy business," and vowed never to run again.
Tom Baffer

the promise of New York that would bear fruit over the next decades. His very energy seemed to sweep away cobwebs and pessimism and announce a new day for the city.

It is my pleasure to acknowledge, on behalf of the Museum of the City of New York, the work and dedication of the people who made the exhibition and book possible. Gregory Dreicer, Hall Smyth, and Charlotte Brooks of Chicken&Egg Public Projects developed, curated, and designed the companion exhibition *New York Comes Back* at the Museum of the City of New York. Also indispensable was our exhibition advisory committee: Diane Coffey, chair, George Arzt, James Capalino, Michael Goodwin, Richard Lieberman, John LoCicero, Ronay Menschel, John Mollenkopf, Jonathan Soffer, Henry Stern, and Robert Tierney. Editor Michael Goodwin, columnist for the *Daily News*, conceived the book and shaped the contributions of our stellar cast of essayists: Ken Auletta, James Brigham, Evan Cornog, Michael Gecan, Pete Hamill, Judith Kaye, Ronay Menschel, John Mollenkopf, Joyce Purnick, Sam Roberts, Joe Rose, Al Sharpton, Henry Stern, Alair Townsend, Carl Weisbrod, and Johnny Ray Youngblood. I am grateful to them all, as well as to the New York *Daily News*, particularly Les Goodstein, president and chief operating officer, and Eric Meskauskas, director of photography, for their partnership and for supplying the photographs that illustrate this volume.

Susan Henshaw Jones is President and Director of the Museum of the City of New York.

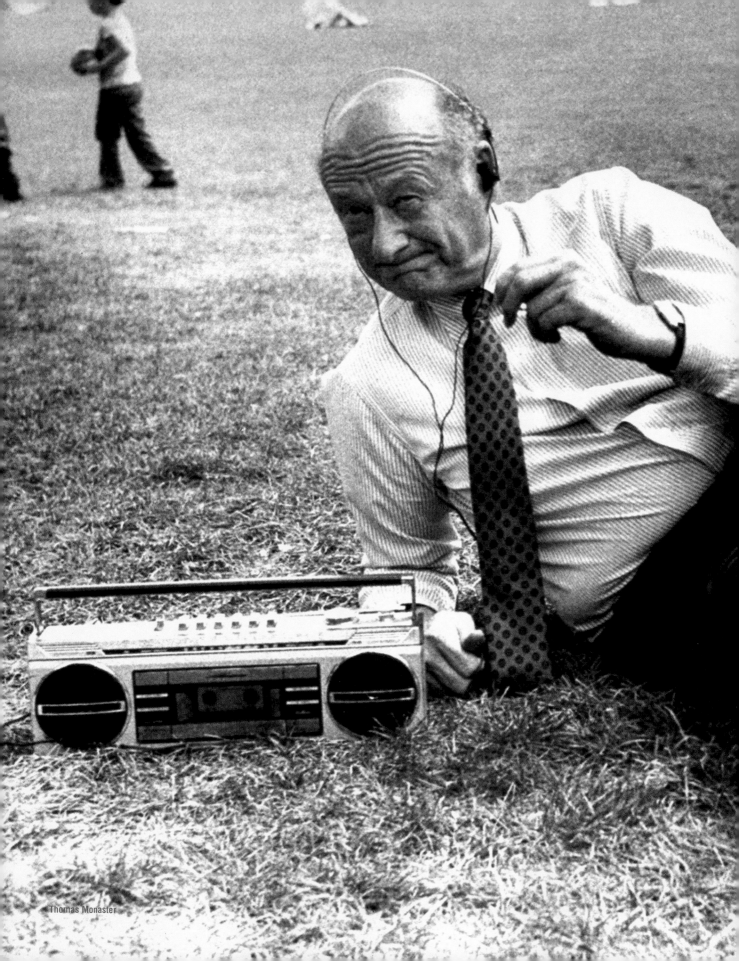

INTRODUCTION
BY MICHAEL GOODWIN

Journalism is the rough draft of history, the maxim says, implicitly conveying both a warning and a promise. The warning says be careful, what you see and read now is not the final word, merely the best we could do under the pressure of time, space, and circumstance. The promise is that there will be a second or even third draft as new facts and ideas emerge. The hope is finally to get it right, to come as close to the bull's-eye of truth as is humanly possible.

And so it is with Edward Irving Koch and the essays included in this seminal collection. Almost 16 years after voters made him a private citizen, the 105th mayor of the city of New York is the focus both of these pages and of the companion exhibition at the Museum of the City of New York scheduled to open in October, 2005.

It is perfect timing for a fresh perspective. Koch is 80 now and his 12 remarkable years in City Hall are ripe for a second look. Seen through the lens of hindsight and his successors, we aim to more accurately assess the fruits of the Koch years and his impact.

Ah, the Koch years. Merely to think of the period, from his upset election in 1977 to his resounding defeat in 1989, is to be drawn inexorably back into the boiling cauldron of those times. It was not a passive and quiet time in Gotham. Like Ed Koch, those years were full of energy and contention, change and growth, and more than a few hiccups. There were periods when the city seemed to career from one near-miss with disaster to another, only to emerge with the sun shining and its people moving forward, if not always smiling.

Mayor Koch was everywhere, in your face wherever you turned. He was the "Media Mayor," a best-selling author, our civic cheerleader, king of the hill, passionate protector of the middle class, scourge of the "wackos" and "crazies" who would rob and ruin his beloved New York. One moment he entertained with his animated expressions and dagger-like one-liners, and the next he infuriated with an uncanny ability to step on toes without noticing or caring. He was never boring because he was never bored.

Everyone else was second fiddle as his one-man band dominated city life in ways that far exceeded the statutory bounds of office. He was so omnipresent for so long that it was said a generation of children grew up thinking Koch's first name was Mayor. Ed Koch had no peer at grabbing the spotlight in modern memory—the last was Fiorello LaGuardia.

Yet that spotlight can distort as much as it reveals. The fact that Koch was "good copy" for the scribes crammed into City Hall's legendary Room 9, the press room, often worked against the larger goals and accomplishments of his administration. What should have been, say, the important announcement of a plan to repair bridges could get consumed by the mayor's off-handed slap at a rival. So much the better for TV ratings, and the mayor's, if the cameras happened to be rolling.

That Koch loved the limelight was obvious, but it was just as true that the limelight loved him. Even when he tried to play it straight, the media often came looking for a way to push his buttons—and was ready to pounce if he obliged. Baiting your hook to get the mayor to bite at your question was part of the daily routine for reporters in Room 9. I know because I was one of them.

My years as the City Hall bureau chief for *The New York Times*, from mid-1981 through 1984, were my formative experiences as a journalist. Koch was extremely accessible—far more so than his predecessor and his three successors—as was most of his administration. One result is that virtually any news story in New York was considered incomplete unless it contained a quote from Koch. As he once said, if a bird drops dead in Central Park, the mayor gets blamed. One suspects he wouldn't have wanted it any other way.

As the city moved steadily, if not always smoothly, from financial peril to stability, Koch became the national image of back-from-the-dead New York. His spunk, toughness, and man-on-the-street smarts personified New York in the minds of many New Yorkers, and for the rest of America and large parts of the world. His City Hall was a feast of stories, personalities, and politics. I felt like I had a front row seat at the circus every day.

Such a close vantage point, however, is usually not the best spot for seeing events in their proper perspective. For me, a moment of big-picture insight came from the late senator Daniel Patrick Moynihan. During an interview in 1984 in his Senate office, Moynihan made a bold prediction. "History will record Ed Koch as having given back New York City its morale," he told me.

He went on to talk about how Governor Hugh Carey "saved the city," but that the heavy state oversight that came with Carey's fiscal help took away the city's independence. "But people don't feel that," Moynihan said. "And it's because Ed Koch has made them feel we are running ourselves again and we are on our own and we are the way we have always been. And that is a massive achievement."

As you can tell from the title of our collection of essays and the exhibition, we believe Moynihan's prediction was right on the money.

That interview was for a book I was writing on Koch. My co-authors, Arthur Browne and Dan Collins, and I hoped to fill in the blanks of Koch's life and early career in ways that daily newspaper work would not allow. The result, *I, Koch: A Decidedly Unauthorized Biography of the Mayor of New York City, Edward I. Koch* (Dodd, Mead, 1985) was, understandably, not a favorite of the mayor's. I was gone from City Hall before it was published, having asked for a change of assignment at the *Times* by telling my editor the book was my final word on Koch.

Not quite. Indeed, when I was the Editorial Page editor of the New York *Daily News* a decade later, Koch wrote a column for our Op-Ed page. I was Ed Koch's editor! In subsequent years we've shared a few meals and many laughs and stories. That our politics are now far more similar than different was summed up in a recent e-mail exchange. When I sent word that I liked one of his commentaries ripping my old paper, the *Times*, for its knee-jerk liberalism, he wrote back a classic note: "Good. We are in accord. One or both of us has become more moderate."

I am grateful to Susan Henshaw Jones, president and director of the Museum of the City of New York, and her deputy, Sarah Henry, for the chance to help guide this new assessment of Ed Koch's mayoralty. As we approach 28 years since he first stood on the steps of City Hall and took the oath of office, the historic significance of what he accomplished by putting the city's fiscal house in order is beyond dispute. That no one since has dared revert to the wholesale sleight of hand that got New York in trouble before he took office is not just a matter of law. Ed Koch set a standard by showing what could be done in the worst of times. The drama of those days, and a precise retelling of the decisions and strategies, is the subject of our fiscal essay.

That's just one example of why these pages are essential to a deeper understanding of Koch's mayoralty. Our stellar list of authors contains no rookies. Each essay has been written by someone with first-hand experience and knowledge of the events and issues described. Some, such as Alair Townsend and James Brigham, were key members of the administration. Ronay Menschel and Henry Stern have both

known Koch since the 1960s and are uniquely qualified for their reports. Menschel was involved in the efforts to invest in parks and cultural institutions and Stern captures how Koch stays relevant to the city's political and civic life. Evan Cornog, who earned his stripes by serving faithfully as Koch's press secretary, cleverly dissects the media habits of the Media Mayor.

John Mollenkopf and Michael Gecan and Reverend Johnny Ray Youngblood are independent experts in their fields of demographic changes and affordable housing, respectively. New York State's chief judge Judith Kaye writes eloquently and persuasively about Ed Koch's judicial reform, one of his proudest achievements. And, in perhaps the most surprising essay, Reverend Al Sharpton offers a touching tribute to Koch on the topic of race relations. Because I witnessed the meeting in a Manhattan restaurant that Sharpton cites, I can vouch that the greetings between he and Koch were as jovial and heartfelt as he describes.

It is said that what steel is to Pittsburgh, real estate is to New York. With that in mind, we present two insightful essays about economic development issues during the Koch years. Insider Carl Weisbrod recounts the tortured trail of Times Square's revival and argues that Koch deserves the lion's share of credit for that great urban success story. Developer and former Giuliani official Joseph Rose, on the other hand, gives the mayor credit for specific development initiatives, but says the most important contribution Koch made was to keep government out of the way of the private sector so that the city's economic recovery could take place.

Finally, our authors include four of the finest journalists ever to work in New York. Legendary story-tellers Pete Hamill and Ken Auletta present riveting essays; Auletta shows not only how Koch pulled off an upset victory in 1977 but also why it was important for New York. Hamill recalls the mayor's surprisingly exuberant personality, one that seemed to bloom from the minute he took office, and concludes that the mayor's style was very much a part of his substantive success. Joyce Purnick and Sam Roberts, a mighty duo from the *Times*, turn their skills on two of the key events in Koch's years, his ill-fated decision to run for governor in 1982, and the scandals that marred his third term, respectively. Speaking of third terms, Koch could be the last New York mayor to get that many. The city now limits mayors to two consecutive four-year terms.

Notwithstanding these excellent contributions, there is much ground these pages do not cover. There are no essays devoted to Koch's background, his rise through Greenwich Village politics or even his delivering the final defeat to the legendary Tammany Hall machine. Nor do we attempt a service-by-service analysis of his mayoralty. Little is said, for example, about education or crime. While both issues were surely important, they did not provide the defining moments they would for later mayors. Some key players on his team make only cameo appearances, as do some successes, such as his winning a labor concession we now take for granted—that sanitation trucks would have two men aboard instead of three.

Such willful omissions, of course, fit perfectly with the idea that history will go through several drafts as it searches for the final and complete truth. In the spirit of that quest, we offer these important and expertly crafted essays about the man who, as Pat Moynihan declared, gave back to New York City its morale.

Michael Goodwin was the *New York Times* City Hall Bureau Chief from 1981 to 1984, and co-author of *I, Koch: A Decidedly Unauthorized Biography of the Mayor of New York City, Edward I. Koch* (Dodd, Mead, 1985). He is a columnist and former Executive Editor of the New York *Daily News*. As Editorial Page Editor, he led the newspaper's editorial board to the 1999 Pulitzer Prize.

LAST WIN
The mayor was all smiles after he was elected to his third term in 1985.
Paul Demaria

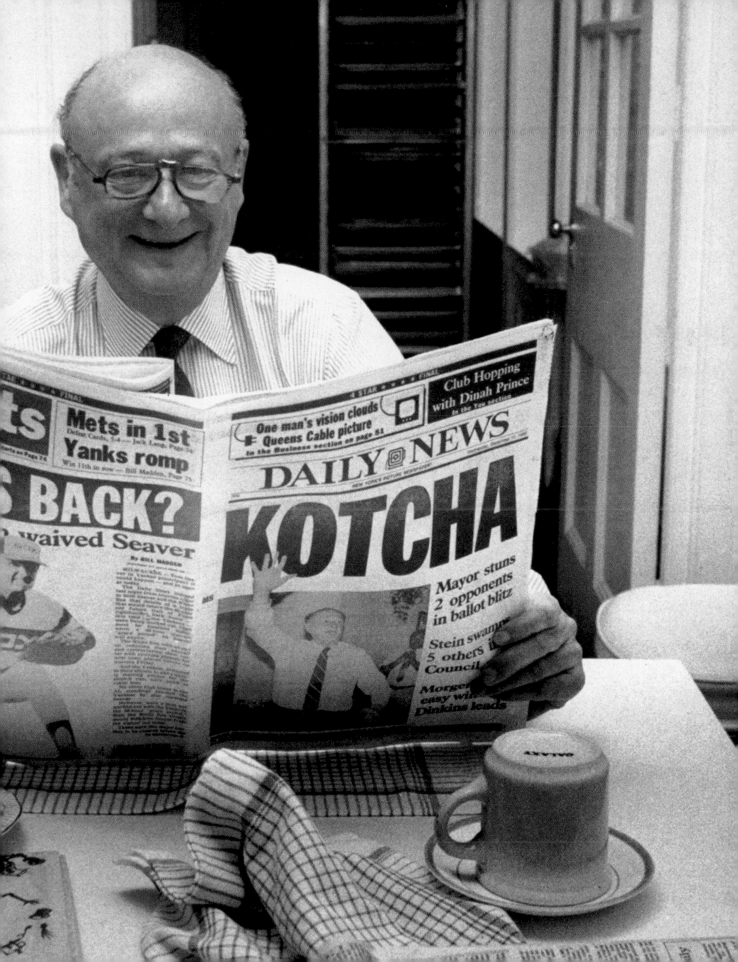

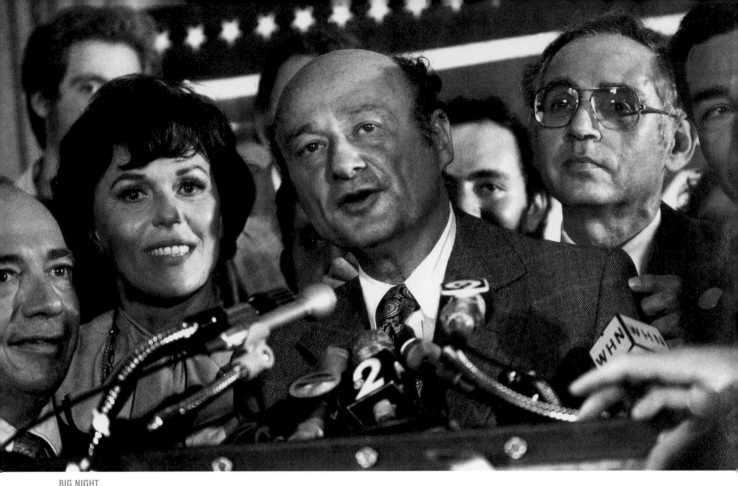

BIG NIGHT
With Bess Myerson at his side, Koch celebrates a runoff victory over Mario Cuomo for the Democratic mayoral nomination.
Charles Ruppmann

1977: THE BEST MAN WINS
BY KEN AULETTA

When Ed Koch presented himself on the mayoral runway in 1977, he was widely perceived to be a smart but boring congressman, a drone, a tall Abe Beame. He lacked the sassy flair required to galvanize New York, it was said. He was too liberal, too divorced from the lifestyle and concerns of the middle class. With seven Democratic and two Republican mayoral candidates modeling that year—incumbent Mayor Beame, Congresswoman Bella Abzug, New York secretary of state Mario Cuomo, Manhattan borough president Percy Sutton, former Bronx borough president Herman Badillo, businessman Joel Harnett, Republican senator Roy Goodman, and radio host Barry Farber—Koch attracted few flashbulbs at first.

Every candidate faced the same painful reality—New York City stood on the precipice of bankruptcy, reeling from a budget deficit that would exceed $1 billion and total debts that swelled above $20 billion. At the same time, the city's tax base had eroded. Jobs were disappearing fast, and since World War II, 2 million middle-income residents had moved out, and almost 2 million poor residents had taken their place. The power of the next mayor would be diminished significantly because he would have to share it with a state government that had usurped Mayor Beame's fiscal powers, and a federal government that had eased the fiscal crisis by agreeing to loan guarantees.

A sense of anarchy gripped the city in the summer of 1977. Citizens worried about the economic collapse of their city. They worried about Son of Sam, a serial killer who was on the loose, arousing the kind of physical terror that would surface again after 9/11. A power blackout stilled city lights and air conditioners, creating more anxiety. And New York City was only in the third inning of a nine-inning fiscal drama. At stake were the pensions and livelihoods of its employees, the loans of its banks, the value of its real estate—the very economic vitality of the world's premier city.

Yet a Maginot Line divided the candidates for mayor. On one side of the line were those who believed the primary blame for New York City's fiscal disorder did not originate with city officials. Whatever their ideological differences, the initial mayoral front-runners, Beame and Bella Abzug, agreed—the fiscal crisis was less the fault of past local officials or tax and spending policies than of federal neglect. Most of the candidates believed the federal government had to pour more resources into the city; they embraced the notion vividly captured in the famous *Daily News* headline, "Ford To City: Drop Dead." They believed the city was a victim of forces beyond its control.

Ed Koch was on the other side of the line. "I believe the answer to our problems lies not in Washington or Albany, but in New York," he said repeatedly. "The mayor has to know when to say no." Because city employment consumed the lion's share of the city's budget, he believed the next mayor had to curb these costs. He went before the city's largest municipal union, DC 37, and endorsed a residency requirement for all new city employees. He assailed spending, denouncing a new police union contract endorsed by Beame because it gave cops more money, more hours off between shifts, and two days off for donating a pint of blood, while offering few productivity improvements. Koch, unlike most liberals, was as wary of municipal unions as he was of any special interest, including bankers. While he spoke out on wasteful city contracts, treating these as a basic consumer issue, his opponents, including Mario Cuomo, were silent.

Koch stood out in another way—he had an unmatched lust for the job. He wasn't ashamed to buttonhole voters, or prospective givers. From his headquarters one day, he phoned a total stranger, Marcol Lindonbaum, who ran a New Jersey propane gas company. "I'm running for mayor and need your help," Koch announced. "Would you donate $1,000 to my campaign?" Lindenbaum was stunned, and stammered, trying to get off the phone. Koch would not let him escape—until Lindenbaum agreed to surrender $200.

Just as he was about to hang up, an aide whispered something to Koch, who suddenly barked into the phone: "Now I know who you are. You're the stepson of Max Stern, and you should give more than $200!" He got $500 out of Lindenbaum.

Every office-seeker wants the job or they would not endure the indignities of running. But Koch wanted it more. He hired David Garth as his chief media and campaign advisor. Garth had guided Republican John Lindsay's City Hall victory and had helped Hugh Carey become governor as a Democrat.

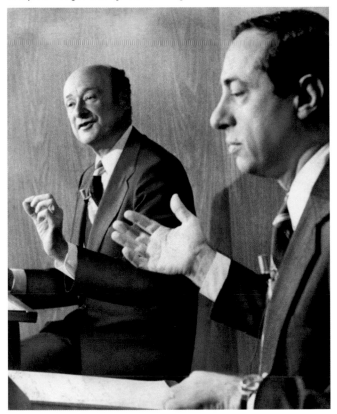

HAND TO HAND
Koch and Cuomo face off in a debate held at the *Daily News*.
Jim Hughes

FINAL ★★★

DAILY ◉ NEWS

Cloudy, showers, 85.
Cloudy tonight, 60s.
Sunny tomorrow.
Details, page 79.

Vol. 59. No. 39 New York, Wednesday, August 10, 1977 Price: **20 cents**

WANTED

Son of Sam

This is new sketch released by police hunting for Son of Sam. Drawing is based on descriptions by witnesses to shootings of Stacy Moskowitz and Robert Violante and previous shootings.

Stories on page 3

Descrition: Male, whti,e 25 to 32, 5'8"-5'9", 165-175 lbs, good athletic type build, clean shaven, dark almond-shaped eyes, dark wavy hair, sensuous mouth, high cheekbones.

Clothes: **Jacket**—blue denim
 Pants—blue denim, slightly flared
 Shirt—bluish grey Qiana with small kidney-shaped design spaced 3" apart
 Shoes—blue denim with narrow white band.

Notify special homicide task force at 109th Precinct with information on suspect: Call 961-9613 or 844-0999.

TERROR
New York was on edge in the summer of 1977 as a mad killer stalked young couples and taunted police with letters.

Neither Garth nor Koch worried about being nice or beloved. They wanted to win.

Koch's great strength was that he knew who he was and had a clear mission in mind. He was a realist. He would not allow liberal compassion to cloud his view. He believed the city required not just bold but zestful leadership. Koch had the good fortune that what he believed both matched the public mood and the needs of the city. Residents wanted a leader, not a conciliator. They wanted a tough sheriff to restore order.

Koch fit the bill. He could not easily be squeezed into either a "liberal" or a "conservative" box. He was a liberal on civil liberties, gay rights, and federal spending to assist cities; he was a conservative on eliminating budget waste, ending poverty program "rip-offs," and opposing race preferences. Why was it "conservative," Koch suggested, to speak out for the public interest, to treat work rules as a basic consumer issue? Why was it "liberal" to maintain the status quo in New York? Koch called himself "a sane liberal," and resembled a good many ex-communicants in reserving his harshest words for those who remained members of his old church. "Knee-jerk liberals," he called them, and said, "I don't believe in half their crap. That government has to become bigger. That government is better if it does more."

Because the public was looking for more than dollar honesty—after all, Beame was personally honest—by the summer people were paying attention to Koch. A sense grew that Koch represented a different kind of honesty, a leader unafraid to stand up for the common interest, someone more willing to say no than yes.

Koch actually finished first in the early September party primary, with only 20 percent of the vote. Because no candidate received anywhere near the minimum 40 percent needed to win the nomination, the rules required a runoff between Koch and Cuomo, who finished second.

The differences between them were often stark. Cuomo spoke often of "unity," Koch of "leadership." Cuomo emphasized his mediator skills, Koch his skill with a blowtorch. Cuomo tried

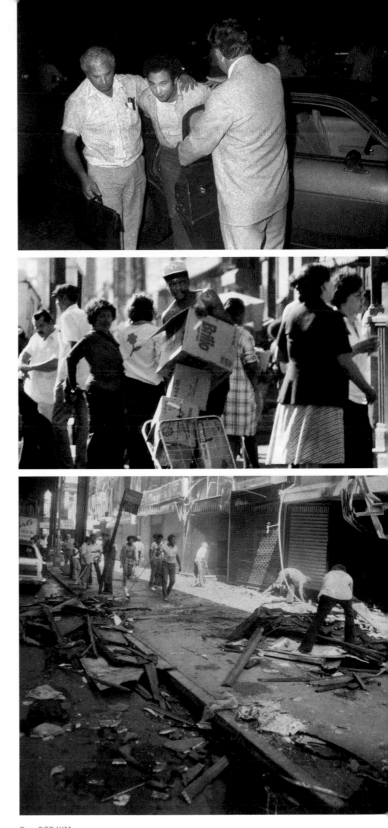

Top: GOT HIM
The cops arrest David Berkowitz on August 11, 1977, who admits he's the Son of Sam killer.
Alan Aaronson

BLACKOUT
Widespread looting and devastation followed the power failure on July 13, 1977.
Center: James McGrath
Bottom: Willie Anderson

to make people feel good, Koch to make them feel overwhelmed or guilty. Cuomo became the herald for the establishment, a man of reason, Koch seized the mantle of underdog, fighting for the citizenry. Although Cuomo came from blue collar Queens and was a poet of the middle class, Koch was perceived as their champion. It was not unimportant that Koch was endorsed by the two tabloids, the *New York Post* and New York *Daily News*, and Cuomo by *The New York Times*.

Still, many were vexed by the choice. They worried that Koch listened too little and Cuomo too much, that Koch had a lust for combat that would polarize New York, while Cuomo would seek not to offend. Koch, as Booth Tarkington said of Teddy Roosevelt, enjoys "the fun of hating," a trait visible as he goaded voters who challenged him or fumed at friends who endorsed someone else. By contrast, Cuomo was probably a better, more generous and introspective human being. Of politics he would muse aloud, "Maybe I'm miscast," provoking critics to label him a Hamlet. In fact, he resembled Plantagenet Palliser, the failed prime minister in Trollope's majestic political novel. Wracked by doubt, "he becomes fretful, and conscious that such fretfulness is beneath him and injurious to his honour. He condemns men in his mind, and condemns himself for condescending to condemn them."

In another primary five years later, this one for governor, Mario Cuomo lusted after the office and went on the offensive, besting an uncertain Ed Koch. But in the mayoral runoff, Cuomo's temperament was ill suited for the times. For those (like me) who were enthralled by Cuomo's grandeur, in the end the real conflict was not between Koch and Cuomo but between the memory of Cuomo the man and the reality of his candidacy for mayor. Inevitably, campaigns test candidates. We can learn how well they delegate, the caliber of the people they surround themselves with, whether they are disciplined, decisive, and calm under pressure, and if they understand the truly vexing choices they must make. In this contest, we learned that Koch was better prepared than Cuomo.

He was far from perfect. He sometimes pandered, talking incessantly about capital punishment, for instance. But at a time when voters needed to know what a candidate would do at this fateful moment in the city's history, Koch addressed voters as adults. When Koch was asked about future city layoffs, he said they were "unavoidable"; Cuomo said they were "undesirable." Koch understood that in 1977 there was often no middle ground, Cuomo did not.

In a vicious runoff, with rumors floating that Koch was gay and that Cuomo had ties to the mafia, Koch bested Cuomo. With Cuomo on the Liberal ballot line, they would face off a third time in November's general election. Koch won easily.

The flaws Koch sometimes displayed in the campaign—his narcissism, his tendency to shoot from the lip—became more apparent when he was mayor. He often asked the wrong question. "Hi, how am I doing?" rather than "Hi, how's the city doing?" But as campaigns can reveal much about a candidate, holding an office can also transform people. As a member of Congress, Koch did not dominate a room, despite his height. As mayor, he became much more comfortable with the bully pulpit and reveled in his megaphone. The public enjoyed his humor, his willingness to do battle with entrenched interests, his intellectual honesty, and his sheer joy in being mayor.

Ed Koch sought a mandate from voters to confront reality, which is what he did, magnificently.

Ken Auletta covered the 1977 mayoral campaign for the New York *Daily News*, where he was a columnist for 16 years. He wrote a two-part *New Yorker* profile of Mayor Koch in 1979, and a two-part *New Yorker* profile of Governor Cuomo in 1984. He is the author of ten books, including four national bestsellers. He writes the Annals of Communications for *The New Yorker* magazine.

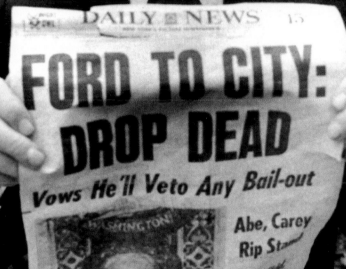

THE DIRTY DEED
Mayor Abe Beame, in 1975, holds the most famous headline in New York newspaper history.
Bill Stahl Jr.

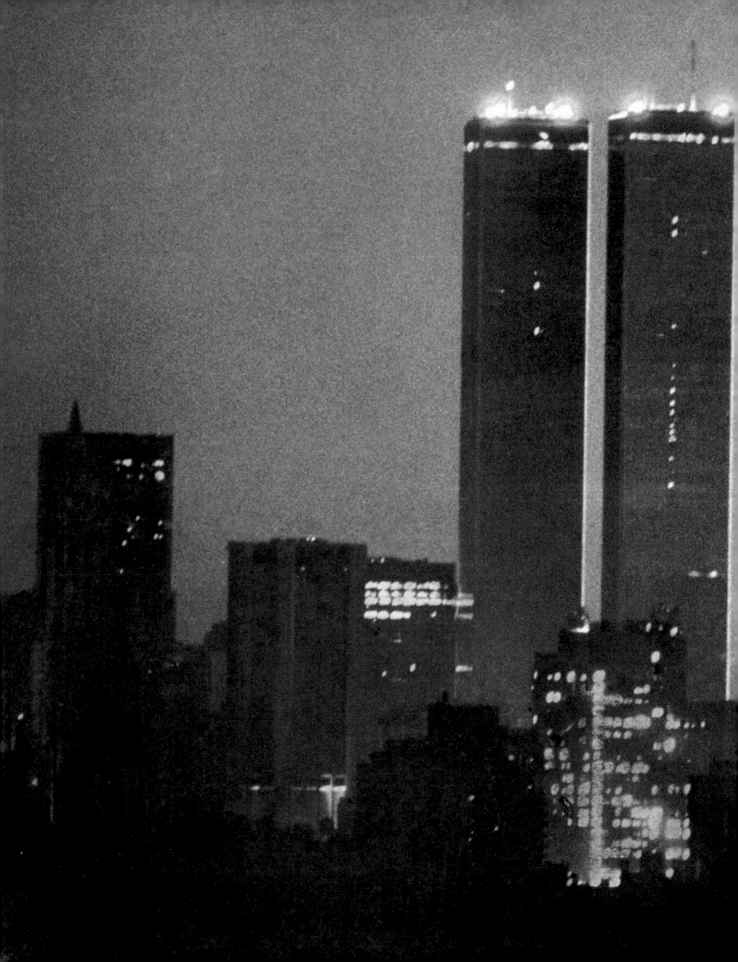

DARKNESS
Generators from the World Trade Center illuminate a blacked-out skyline.
Thomas Monaster

OCTOBER SURPRISE
Koch infuriated President Carter by meeting with Republican candidate Ronald Reagan at Gracie Mansion, late in the 1980 campaign. Reagan returned the favor by saying he was impressed with the city's recovery under Koch, and signed on to loan guarantees.
Willie Anderson

THE FISCAL CRISIS
BY JAMES R. BRIGHAM JR. AND ALAIR TOWNSEND

When Edward I. Koch was sworn in as the 105th mayor of New York just after midnight on January 1, 1978, his administration had 20 days to submit a four-year financial plan to the U.S. Department of the Treasury. The treasury had lent the city $2.6 billion to support its short-term cash requirements, all of which was due to be repaid by June 30, the end of the city's fiscal year. Secretary of the Treasury W. Michael Blumenthal wanted to know not only how the city would repay its debt to the treasury, but also how it would become financially self-sufficient over the next four years.

Since the famous headline "Ford to City: Drop Dead" in the New York *Daily News* in 1975, there had been a growing recognition that the financial collapse of the nation's largest city, indeed the world's capital city, would not only affect the U.S. economy, but would also ripple through the American and global economies. Political and financial leaders believed there was an appropriate federal role in the city's recovery if the city had a convincing and rigorous plan to set its fiscal house in order.

The state-created Emergency Financial Control Board had controlled the city's budget and contracts since 1975. City finances were managed principally by the Municipal Assistance Corporation, known as "Big MAC." The state had created MAC to refinance the city's $6 billion in short-term notes on which the city had technically defaulted in 1975, precipitating the fiscal crisis. With the U.S. Treasury and state agencies controlling the city's budget and finances, elected officials were barely more than observers to the political process. Ed Koch believed this violated core principles of democracy. He had based his campaign and would stake his first term on restoring the city's fiscal integrity and returning governance to its elected officials.

His plan consisted of four related elements:

• Balance the budget under Generally Accepted Accounting Principles in four years.

• Negotiate new contracts with all the municipal labor unions to replace existing contracts that would expire in six months.

• Pass federal legislation to provide long-term loan guarantees for rebuilding the city's crumbling infrastructure. This was seen as central to revitalizing New York's economy.

• Regain an investment-grade rating on city bonds and return to public credit markets.

Federal loan guarantees were the linchpin of the plan.

GETTING THE FEDERAL GUARANTEES
Ed Koch was a respected five-term member of the U.S. House of Representatives. His former colleagues greeted him enthusiastically as he stormed the House office buildings pressing his case for the loan guarantees. It was clear that they wanted him to succeed. The legislation was under the jurisdiction of the House Committee on Banking, Finance, and Urban Affairs. The committee had acted quickly on the administration's proposal and reported a bill out to the full House by a 3 to 1 margin. New York senators Daniel Patrick Moynihan and Jacob Javits introduced an identical bill in the Senate in May.

The Senate Committee on Banking, Housing, and Urban Affairs, chaired by Wisconsin's maverick senator William Proxmire, held hearings in early June. New York's political, financial, and labor leaders had coalesced around the city's four-year plan and strongly supported the legislation at

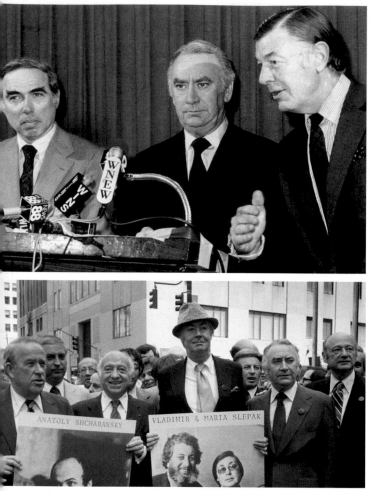

Top: HEAVY DUTY
Felix Rohatyn, Governor Hugh Carey, and Municipal Assistance Corporation chairman George Gould helped guide the city through crisis.
Dan Jacino

Bottom: LINEUP
Senators Henry Jackson, Jacob Javits, and Pat Moynihan, Governor Carey, and Mayor Koch were united in getting the city federal help and here, supporting Soviet dissidents.
Harry Hamburg; © AP/Wide World Photos

the hearings, as did Secretary Blumenthal, New York governor Hugh Carey, and MAC chairman Felix Rohatyn.

The mayor was in his element. His congressional experience and energetic and forceful style conveyed the "renaissance" he said was emerging in New York, and he demonstrated an enormous grasp of the political, economic, and financial complexities. After the hearings, Senator Proxmire said he was a "star."

Proxmire had invited Moynihan and Javits, Democrat and Republican, respectively, to attend the hearings. Although Democrats had a large majority in the Senate and the committee, Senate leaders felt it was important that the legislation have strong bi-partisan support. Republican members were particularly skeptical about whether the bill provided sufficient controls and incentives to ensure that the city would succeed. Minority senators John Heinz, a former House colleague of Ed Koch, Richard Lugar, former mayor of Indianapolis, and Harrison Schmitt, former Apollo 17 astronaut, led the successful effort to tighten up the legislation.

In the meantime, New York's senators spoke often and eloquently on the city's behalf. At one point, while minority staff members were crafting tougher financial covenants, Moynihan was appealing to the Senate's better nature by invoking the beauty of Central Park. "The United States has carved Egyptian temples out of the valley of the Nile and brought them to places where they will be safe, we have fixed up temples in Indonesia, shrines in Japan. Are we going to let Central Park disappear from us?"

In the end, the combination of a tough financial plan and broad support for Ed Koch and his city carried the day. The Federal Loan Guarantee Act for the city of New York passed overwhelmingly and was signed into law by President Carter in June, 1978.

BEATING THE CLOCK

Ed had been correct about the "renaissance" of the city. By December, 1979, the city had met all the requirements of the loan guarantee legislation, and New York's economy had clearly improved. The city was required to balance its budget under GAAP by 1982, and Budget Director Jim Brigham had directed his staff and the agencies to prepare a detailed plan for 1981 and 1982 so that the mayor would have a clear picture of what would be required to meet his commitments.

During a conversation with Deputy Mayor Nat Leventhal, *Wall Street Journal* reporter Daniel Hertzberg said, "Why would you guys wait until 1982 to balance the budget? Couldn't you do it this (coming) year?" Leventhal presented the idea at the next budget meeting. Obviously there were significant risks if the city tried and failed, but tremendous

benefits if it succeeded. Because he was in the midst of a two-year budget review, Ed could see that balancing the budget a year early would simply require accelerating the cuts he would have to make in any event to balance the budget for 1982.

His cabinet believed the political and financial communities would strongly support the move, which would improve the chances of implementing the necessary cuts. It was a courageous and, ultimately, wildly successful decision. It also was one of only three decisions during his three terms over which Mayor Koch admitted to losing sleep. At 4:00 AM the day of the announcement, the mayor called his budget director and said, "Jim, are you sure we're doing the right thing?" The budget director was appropriately reassuring.

The decision accelerated the downsizing of the city's workforce that was already underway. Full-time personnel, including teachers and other education workers, declined from 192,465 at the end of June, 1979 to 188,457 at the end of June, 1981. The total had been 226,694 in June, 1975. Police Department staffing fell from 35,447 in June, 1975 to 27,971 in June, 1981. Board of Education employment levels alone declined from 81,970 to 70,062 during the same period.

Despite the painful cuts, the decision was widely celebrated. By the summer of 1980, *The Wall Street Journal* wrote a full-page editorial endorsing the city's plan entitled "Supply Side Saves New York." This was a reference to supply side economics, which the *Journal* had promoted as part of its support of the presidential campaign of Governor Ronald Reagan. Candidate Reagan had been critical of the federal loan guarantees for New York, but Mayor Koch would win him over.

In the final weeks of the campaign, Reagan's campaign managers asked if the mayor would meet with the Republican candidate. Over the sharp objections of the Carter campaign, the two met at Gracie Mansion that October. The mayor declared that Governor Reagan might become our next president, and that there were things we needed from the federal government. Governor Reagan was impressed with the progress the city had made and thought it

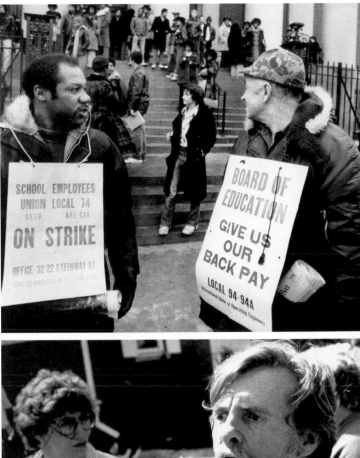

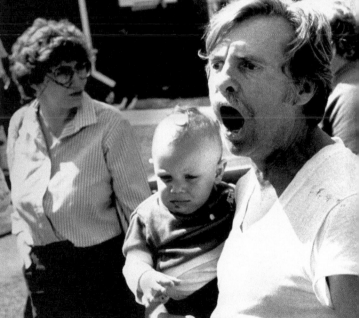

BUDGET PAINS
Striking city workers and angry citizens are a common sight as Koch tries to balance the books.
Top: Richard Corkery
Bottom: Anthony Casale

could serve as an example for the country. That day he endorsed the loan guarantee program and committed to approving the last $750 million.

By the spring of 1981, it was clear that the city's budget for its June 30 fiscal year would be balanced. After a rigorous review, Standard & Poors restored the city's investment-grade rating. The

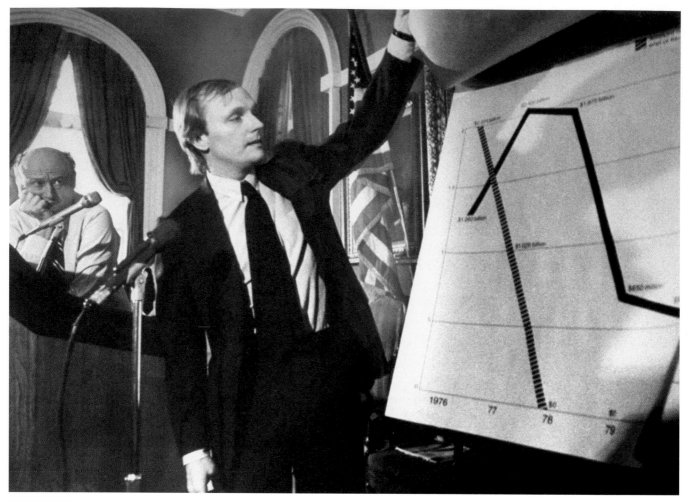

TURNING POINT
Koch watches as Budget Director James Brigham explains how the city plans to balance spending and revenues in 1981.
Willie Anderson

successful public offering of $75 million in bonds in April, 1981 was the city's first since 1974.

The Financial Emergency Act set forth the conditions under which the Control Board's most sweeping powers would "sunset." It became a matter of civic pride for Ed Koch to beat the deadline and the cause of great celebration in mid-1986 when full budget powers were returned to the city's elected officials. It was official: New York City was no longer a fiscal outlaw.

CHALLENGES REMAINED

The worst was over, but there were recurring challenges from the effects of a national recession in the early 1980s, the budget cuts that accompanied the Reagan revolution, and the stock market crash of 1987.

Whatever the fiscal situation, the mayor continued his early practice of reviewing every detail. The OMB staff spent hours in his office each budget cycle, going department by department through the budget. The mayor always sat in the same big leather chair, listening intently as OMB staff presented reestimates, and proposed cuts and productivity and management initiatives. The mayor probed; if productivity improvements were proposed for half of agency x's offices, he would ask, why not for all?

Decisions were made with broad input from the deputy mayors, labor negotiators, lawyers, political advisers, and operations staff. It was sometimes annoying, even painful, for budget directors, whose job was to ensure that the budget would be balanced, but the process was a good one. Ed Koch

was the ultimate decision maker, but his insistence on an open process served him and the city well.

He understood that each of his top advisers had to reflect his or her institutional base first. He had chosen them because of their substantive expertise. He respected that expertise and made sure it was part of his decision-making mix. He wanted professionals who weren't afraid to argue their views strongly. The signal that he'd heard enough and made up his mind was one big raised hand, palm outward. "Stop!" it said.

Like all mayors, he was called upon to make many difficult decisions. His strength lay in being comfortable making the call. He understood that a bad decision could be changed ("mayor culpa"), but that indecision would be crippling.

TROUBLE IN BETTER TIMES

Making the cuts necessary to get the budget back in balance had been painful and at times acrimonious. But, oddly enough, Ed Koch was probably never so popular as when the cupboard was bare. He made saying no a virtue. "We can't spend what we don't have," he endlessly reminded the public and the press. The public warmed to a plain-facts mayor who spoke in ways everyone could understand.

It was more difficult to manage expectations when financial circumstances began to improve as the years went by. Everyone had pent-up needs, priorities, and wish lists. The streets should be smoother, cleaner, and safer. Street trees needed trimming. Libraries needed new books and longer hours. Schools needed practically everything. Municipal workers wanted better pay. There were by far more claims than could be accommodated. If some things are possible, why not all things—and especially, "why not my thing?"

The fragile consensus was severely tested when there was a bone to fight over, a spare nickel to contend for. Fiscal monitors, rating agencies, bondholders, the business community, and New Yorkers of every station had demands that were not easily reconciled. The classic schisms in New York reopened as the politics of prosperity, or at least semi-prosperity, replaced those of the fiscal crisis.

The battle over the homeless was a case in point, with Ed under broad attack for not doing more. There seemed to be an open-ended demand that would be impossible to meet at any affordable cost. No matter what he proposed, critics demanded more. Homelessness came up at almost every press conference. Each time, he answered in great detail, covering much of the same ground. He wanted to make it difficult to get a quick sound bite on a complicated subject.

Anecdotes helped him make his points. He told about a group of nuns across the river in New Jersey who had a limited number of beds to offer each night. When they were full, they gave people PATH tokens to go across the river where "Ed Koch will take care of you."

He visited shelters and there found an apparently able-bodied young man around 21 years old. The mayor asked whether the man had friends in the area. "Oh yes." And did he have a family? "Oh yes, on Long Island." Well then why wasn't he living with his family? "Please mayor, I'm old enough to take care of myself."

In the 1960s, New York had trouble maintaining boundaries between what it could and couldn't afford. In the 1980s, AIDS, homelessness, and crack threatened to erase the boundaries yet again. Having brought the city out of its fiscal hole, Ed Koch was determined that it not repeat the mistakes of the past.

James R. Brigham Jr. was New York City Budget Director from 1978 to 1981 and Chairman of the the city's Public Development Corporation from 1981 to 1985. He is currently Managing Director of HealthpointCapital LLC, a merchant bank focused on the orthopedic industry.

Alair Townsend served in the Koch administration from September, 1981 to January, 1989, first as Budget Director and then as Deputy Mayor for Finance and Economic Development. She is currently the Publisher of *Crain's New York Business*.

PAY ATTENTION
Koch marches with Robert McGuire, left, in the Saint Patrick's Day Parade. Never one to get lost in the crowd, Koch was fond of announcing his arrival at public events with, "It's me, I'm here."
Dan Farrell

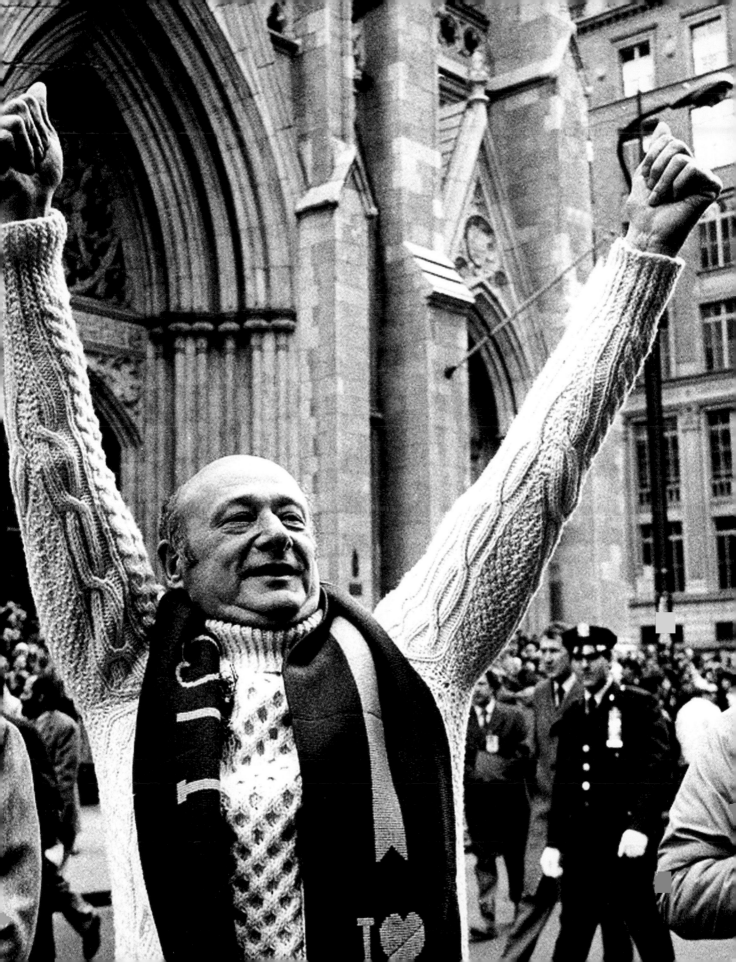

ON THE SUBWAY
Koch showed the common touch by taking the subway
to work, and jawing with other riders, in 1978.
James McGrath

PERSONALITY WITH A POINT
BY PETE HAMILL

On January 1, 1978, the day Edward Irving Koch was sworn in as the 105th mayor of New York, there was little jubilation in the city air.

The reason was simple: we had gone through a long, terrible time. The fiscal crisis erupted in the fall of 1975, and swiftly led to layoffs of cops, firemen, sanitation workers, teachers, librarians—all those noble citizens who maintained the city as a civil society. Not surprisingly, life got worse. Fewer policemen struggled to control the gathering urban storm of youth, drugs, and guns. Garbage littered the city's streets. The Bronx was burning down, along with parts of Brooklyn and Harlem, as many landlords employed arsonists to collect insurance and flee the city. Legions of homeless people, including women, children, Vietnam veterans, the mentally disturbed, heroin addicts, and alcoholics, began roaming the streets. The bag lady became a symbol of New York misery.

By the election year of 1977, Ed Koch was given only a small chance when he offered himself as mayor to the voters after nine years as a congressman. Most knew little about him. He appeared to be a classic Greenwich Village liberal who had opposed the war in Vietnam and supported the struggle for civil rights. At 52, he was a lifelong bachelor. He was losing his hair. Many New Yorkers were longing for a tough guy, and in the world of media stereotyping, that did not seem to be Ed Koch. But in 1977, other things began to happen.

On July 13, a power failure paralyzed the city and lasted 25 horrendous hours. I remember roaming the city that first night with a few other reporters, moving through streets as dark as any from the first eight decades of the 19th century. But there were actions taking place that were far worse than the loss of light. Fires erupted everywhere, more than a thousand of them, and in the garish orange light of the flames we could see the looters.

They roamed the night in a kind of frenzy, smashing windows, carting away some of the worst junk of the 20th century: TV sets, record players, shoddy clothing, paintings on velvet. The undermanned police made 3,776 arrests; they could have made thousands more. When dawn finally arrived, we shared a sense that this terrible night would change us all.

The images of the blackout were seen in newspapers and on television news (after power was restored), and for many New Yorkers they carried one basic message—the city was out of control. City Hall was in the hands of a clubhouse mediocrity named Abe Beame, who would have trouble giving orders to a sanitation crew. True power—based on the ability to spend tax dollars—was now in the hands of the Municipal Assistance Corporation.

GAME FACE
New York needed a tough mayor, but Koch "often seemed mean and bullying."
Ed Molinari

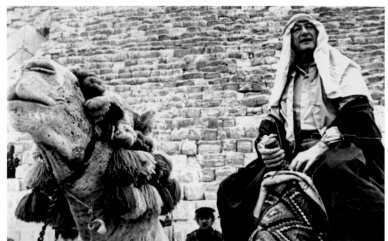

THAT'S ENTERTAINMENT
The mayor loved to ham it up; here he does a Michael Jackson impersonation during the MTV Video Music Awards in 1985.
Richard Corkery

Koch is "Lawrence of Astoria" during a trip to Egypt.
© AP/Wide World Photos

There were too many poor people and too few tax payers; for many middle-class New Yorkers the message was simple—it's time to go. And they began departing for the suburbs. One old friend said, "What the hell, I had the best of this town. But it's over."

Part of the 1977 context of menace was the existence of a faceless maniac who first struck on a July night in the previous year. Using a .44 caliber Bulldog revolver, he shot two young women in a car parked outside a Bronx apartment house. This would be the first of the random killings and woundings that would be part of the New York night for a year. The gunman was David Berkowitz, a 24-year-old sociopath from Yonkers. He killed and he maimed and then wrote letters to the *Daily News* columnist Jimmy Breslin. Berkowitz became better known as Son of Sam. He was arrested, at last, in August, 1977, while the mayoralty campaign was under way, but his presence added to the feeling of many New Yorkers that the city was spawning monsters.

Into this season of fear and despair came Ed Koch. He moved to the right, supporting the death penalty, talking back to black leaders who saw racism as the city's most pervasive problem. He was the ultimate wised-up liberal (later he would call himself a "liberal with sanity"). To combat

doubts about his single status, he campaigned everywhere with Bess Myerson, the former Miss America. He held hands with her, and hinted at romance (in real life, Ms. Myerson had a long-time boyfriend who surfaced a few years later). Astonishingly, all of this worked. The *New York Post*, under its new owner, Rupert Murdoch, endorsed Koch, and promoted him relentlessly. Koch won a runoff and was to be the next mayor.

But his election didn't lift the gray sourness from the daily lives of so many New Yorkers. As the terrible year wound down, I took calls from friends who were leaving for New Jersey or Florida or California, and I knew I'd probably never see them again.

Enter Mayor Koch

There had been no mayor like him since Fiorello LaGuardia in the 1930s and 1940s. John Lindsay had served two terms as mayor, from 1965 to 1973. But he was a liberal Republican from Manhattan's silk stocking district, with no citywide political organization to serve as an early warning system about discontent. In a city of millions of Catholics or Jews, he had no natural ethnic or religious constituency. One result of this missing ingredient was that in times of crisis, his good intentions were not enough. To be sure, Lindsay kept the city

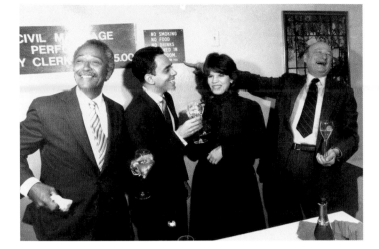

Koch and David Dinkins toast newlyweds Juan and Minerva Torres at the city's refurbished wedding chapel in 1982.
Mel Finkelstein

Koch himself was often The Greatest Show on Earth.
David Handschuh

relatively calm during the era of American urban violence, but during his reign the welfare rolls soared, factories closed, and blue collar anger reached peaks not seen since the Great Depression. To keep peace with labor after the subway strike that marred the first two weeks of his mayoralty, Lindsay gave municipal workers fat contracts and the costs of government increased in a drastic way. Eventually, Lindsay became a Democrat. He ran briefly for president in the Democratic primaries. Nothing helped.

In 1974, he was succeeded by Beame, who was a kind of still life. He had served as the city's controller, presented himself as a prudent and

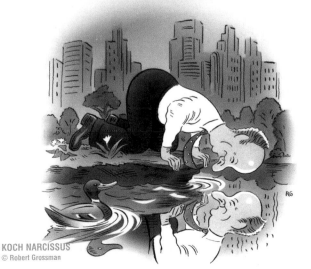

KOCH NARCISSUS
© Robert Grossman

steady hand, and swiftly collapsed under the force of the fiscal crisis. True power passed into the hands of New York State governor Hugh Carey and MAC chairman Felix Rohatyn, while Beame became a symbol of political impotence. By 1976, while he still presided over the stale rooms of City Hall, he was being referred to as "former mayor Beame."

Against that austere, gloomy backdrop, nobody was quite prepared for the arrival of Koch in power. Suddenly, there he was, some mad public combination of a Lindy's waiter, Coney Island barker, Catskill comedian, irritated school principal, eccentric uncle. He seemed to be everywhere, from the steps of City Hall to the scene of a homicide or a raging fire. In the age of McLuhanite rules, he defied the formula—he was hot, not cool. At six foot two, he stood taller than most citizens and his elastic features were made even more familiar by television, where he became a master of the cutting, pithy sound bite.

Koch often talked tough, because he was, in fact, tough. He had been a combat infantryman at the end of World War II, where he served with the 104th Infantry Division, earned two battle stars, and was honorably discharged as a sergeant in 1946. Like most members of that generation, he didn't often talk about the war, but it was in him, part

of his character. He made clear in his tough talk that he thought true New Yorkers were tough, too, and they would get past the bad times together.

He loved squelching hecklers, and at public assemblies he always put down those citizens whose questions he thought stupid or hostile, even older folks who were fragile and tentative. This part of his public act was unpleasant; he too often seemed mean and bullying. After one such outburst, I asked Bess Myerson why he behaved that way. She said, "You have to remember something. Ed Koch has never lived with a woman. Ed Koch has never lived with a man. Ed Koch has never lived with a dog. That's why he's like that."

But there was a larger point to what he was doing. Koch came to power knowing that he could not govern New York in the old way, because the Municipal Assistance Corporation had ultimate control. He chose two ways to take command of his unruly, depressed citizenry. First, he would entertain them, using jokes and scorn and sarcasm to make them laugh, which was a way of bringing a sense of proportion to their problems. More importantly, he would call on their collective toughness, the heritage of the European immigrants and the descendants of slaves. They were part of the city's human alloy, insisting that the only unforgivable sin was self-pity. In his occasionally mean, always argumentative style, Koch seemed to be living according to the old Irish proverb "Contention is better than loneliness."

Loneliness was, in fact, part of his baggage. There were moments in the midst of the political carnival when you could see glimpses of the man behind the act. There'd be a distant, private look in his eyes, just before a speech. Or a sudden loosening of his features during political chatter with strangers. Politicians, like movie stars, often have trouble knowing their true friends, as compared to those who want favors or those in search of reflected glory. In his autobiography *Citizen Koch* (St. Martin's Press, 1992), there is a continuing refrain about his personal loneliness. When the cameras were turned off, and the multitudes had departed, Koch was too often alone.

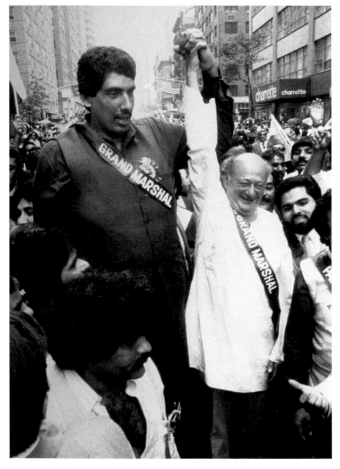

Top: MEET THE MUPPETS
Anything to help the city.
Richard Corkery

Bottom: GIANT STEPS
Mayor Koch with the world's tallest man, Mohammad Channa, in 1985.
Jim Highes

He was never more alone than during the long agony of his third term (1985–89). As a mayor, he could brag that he'd balanced the budget ten straight times. He certainly had been a major factor—if not the decisive factor—in the revival of New York morale. But all around him, corruption scandals came rising from the municipal sewers. There were never any charges against Koch of personal corruption. But the scandals all took place while he was mayor. In the end, he bore responsibility for failures in judgment about his appointees, and a lack of scrutiny of the government he ran. Recounting that dismal time in his autobiography, Koch admitted to wanting to kill himself.

He didn't, of course, and that was good for all of us. Koch remains with us, loving his celebrity, whether appearing on television or strolling down an avenue on a day of bright sunshine. This is certain—he was one of the most important mayors in the city's history. At his best, he moved us forward. He gave us energy and focus. And always, there were the laughs. We were lucky to have him.

Pete Hamill spent four decades in the New York newspaper world. He has published 19 books, nine of them novels, including the best-selling *Snow in August* (Warner Vision, 1998) and *Forever* (Back Bay Books, 2003). His most recent book is *Downtown: My Manhattan* (Little, Brown, 2004). He is a Distinguished Writer in Residence at New York University.

BUSS STOP
Manhattan seniors find Koch irresistible.
Misha Erwitt

Following pages:
SHOW STOPPER
Left: Twiggy and Tommy Tune admire Koch's outfit and foot work during a 1984 roast of political reporters.
Willie Anderson

Right: Koch high-kicking with the Rockettes at *Night of 100 Stars* at Radio City Music Hall in 1985.
Richard Corkery

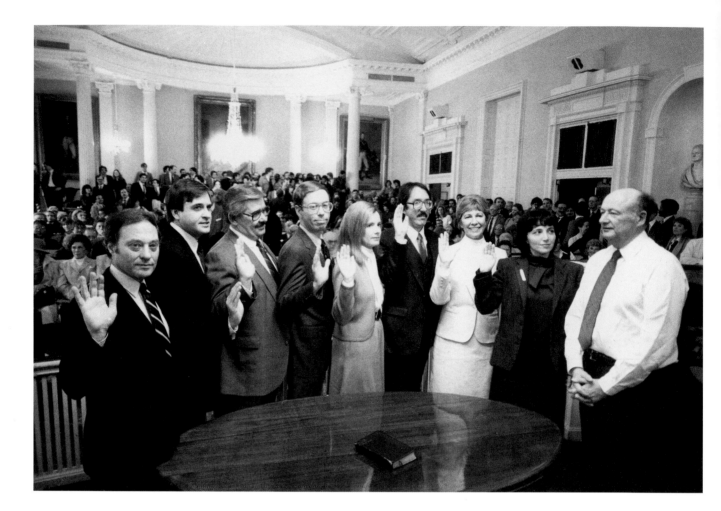

ORDER IN THE COURT
BY JUDITH S. KAYE

Ed Koch's tenure as mayor of this great city was marked by many notable achievements, as this collection of essays documents. Among the most important of those achievements is one that is likely unfamiliar to the public at large today—the establishment of a method of judicial selection intended to de-politicize judicial appointments and ensure judicial independence. He has often spoken of this as one of his proudest accomplishments, and rightly so. To this day and beyond, the benefit endures.

The mayor of the city of New York is responsible for appointing more than 100 judges to ten-year terms on the New York City Criminal and Family Courts, under the provisions of the New York State Constitution. In addition, the mayor may also appoint interim Civil Court judges to one-year terms. Unlike judicial appointments made by the governor and even the president, judicial appointments made by the mayor are made solely by the mayor, and are not subject to legislative ratification. (State Supreme Court justices and city Civil Court judges are elected.)

Prior to Mayor Koch, no public hearing was required before the mayor swore in his nominee. All the more important, then, that the process by which the city's judges are screened, nominated,

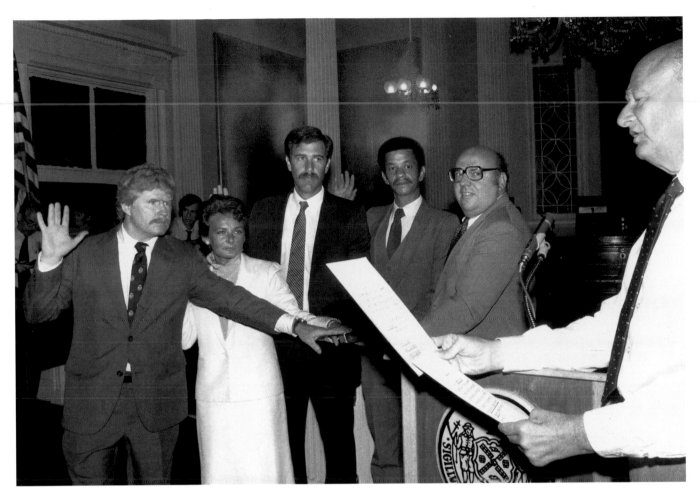

ON THEIR HONOR
Koch changed the way judges were named, replacing clubhouse and political bosses with a professional screening committee and a transparent process. He participates as two groups of his appointees take the oath in 1983.
Opposite page: Harry Hamburg
Above: Jack Smith

and appointed be particularly scrupulous and transparent, so that the public can have confidence in the men and women charged with adjudicating issues of public safety, individual rights, and the welfare of families and children.

At the time that Ed Koch began his first term in January, 1978, judges were typically appointed by a simple process: the mayor or City Hall forwarded the name of an individual to the Mayor's Committee on the Judiciary, which reviewed the individual's qualifications and background, and either approved or disapproved the appointment. The mayor was not formally bound to follow the

committee's recommendation. While well-qualified, highly competent judges certainly came out of that process—indeed, many were reappointed during Mayor Koch's tenure under the system and standards he introduced, and some are still serving with distinction today—the perception was that appointments tended to rest more on patronage than on merit.

Keeping his campaign promise to make "open and prompt" judicial appointments based on merit alone, Mayor Koch took immediate steps to address this perception. He asked his administration to devise a system that would de-politicize the

process and open it to public scrutiny. And he appointed William Leibovitz, then a respected attorney, and who years later would himself become a respected judge, as the chair of the Committee on the Judiciary, to undertake this effort. Just three months into his first term, under Executive Order Number 10 issued April 11, 1978, the existing system was entirely revamped.

First, rather than have City Hall forward a name to the Committee on the Judiciary for its approval, the process would be reversed. The committee was to actively recruit applicants and, after evaluating their qualifications and conducting interviews and background checks, forward names to the mayor—and not just one name for each vacancy, but three names. The mayor would then personally interview these individuals before selecting one as his nominee.

Second, contrary to previous practice under which the public had no input into the process, the committee would then hold a public hearing on the nominee, providing the public with the opportunity for comment and allowing the possibility that the committee might reconsider its recommendation based on information presented at such a hearing. Third, the committee would also evaluate sitting judges for reappointment—something virtually unheard of at the time—and the mayor would not reappoint any sitting judge without the committee's recommendation. The order also provided that judicial vacancies would be filled within 90 days unless additional time was required in the public interest, thus addressing the complaint that vacancies were sometimes left unfilled (or nominations held up) due to political considerations.

Finally, to add to the credibility of the committee's autonomy, the executive order changed the make-up of the panel. Unlike previous mayors, Mayor Koch would no longer appoint the majority of the membership. Instead, he would appoint fewer than half of the members, with the rest appointed by the presiding justices of the First and Second Judicial Departments (which include all of New York City) and, by rotating assignment from year to year, the deans of two of New York City's law schools.

In issuing Executive Order Number 10, Mayor Koch effectively ceded the right to submit candidates for judgeships, changing the nature of the committee's role from one limited to approving or disapproving the mayor's own nominees to one of recruitment and nomination. This alone represented a sea change in the process. In addition, the mayor pledged that he would not appoint or reappoint anyone who was not also recommended by the Judiciary Committee of the Association of the Bar of the City of New York, in effect adopting a second tier of review for all judicial appointments.

The impact was immediate and far-reaching. Within a year, Mayor Koch had appointed or reappointed more than 30 judges. It quickly became clear that changing the process brought with it the added benefit of increasing the number of women, black, and Hispanic attorneys on the bench and thus better reflecting the city's diverse population. In the first five years he was in office, operating under the new standards, Mayor Koch made 57 new appointments and reappointed 66 sitting judges. By the time he left City Hall, he had appointed or reappointed all of the 149 judges of the Criminal and Family Courts.

And the reaction? Amazingly, in a city where no one agrees on anything, the verdict on the quality and the process of judicial appointments was decidedly positive, even from those critical of other Koch policies. The new procedures were widely praised for allowing the committee to function independently, for eliciting names of potential nominees from a variety of sources, for increasing diversity among the city's judges (by the end of his second term, more than one-third of his judicial appointments were women and minorities), and, most importantly, for appointments of high quality.

The day after the November, 1985 election, as he embarked on his third term, Ed Koch once again put the spotlight on judicial selection with a full-page ad in the New York Law Journal seeking qualified applicants for the New York City judiciary, urging attorneys to consider going on the bench and pursuing what he termed the noblest career of all (I agree). The ad was intended to reinforce the

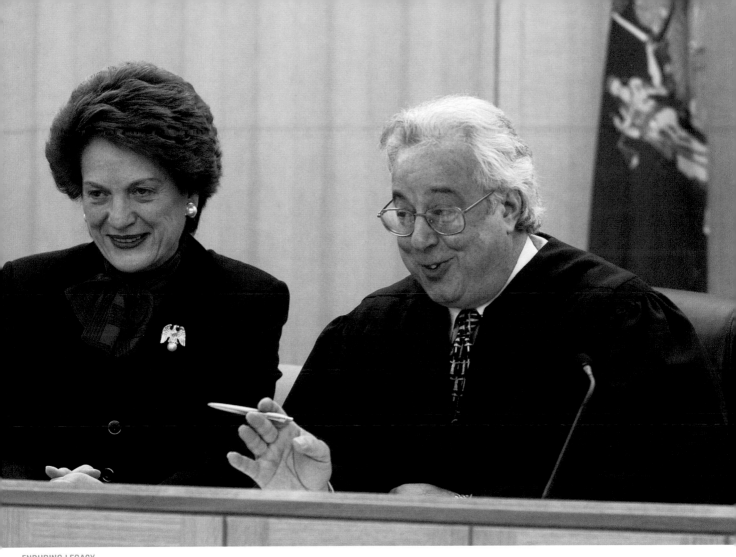

ENDURING LEGACY
The author, seen here with Family Court Administrative Judge Joseph Lauria in 2003.
Craig Warga

openness of the process, reminding potential applicants that they needed no political ties, that an attorney who met the residency and bar admission requirements could be given an initial interview by the committee, and that New Yorkers needed and deserved the very best.

Today, nearly 30 years after Executive Order Number 10, an interested candidate can simply go to the New York City website, download an application, and send it for consideration to the Mayor's Committee on the Judiciary. Under the current mayor's executive order, the committee continues to be charged with recruiting, indeed "encouraging," highly qualified candidates for this unique public service opportunity. As we assess Ed Koch's 12 years at the helm of New York City, we should

remember especially the remarkable contribution he made to the quality and diversity of the judiciary, the integrity of the judicial selection process, and the independence of the judiciary.

Thank you, Mr. Mayor.

Judith S. Kaye has been Chief Judge of the State of New York and Chief Judge of the New York State Court of Appeals since 1993, having served as an Associate Judge since 1983. Appointed by Governor Mario Cuomo, she is the first woman to occupy the top judicial office of New York State as well as to serve on the state's highest court.

ROCKY ROAD
Reverend Jesse Jackson and Koch both seemed to bristle
in each other's presence. They are at City Hall in 1986.
Misha Erwitt

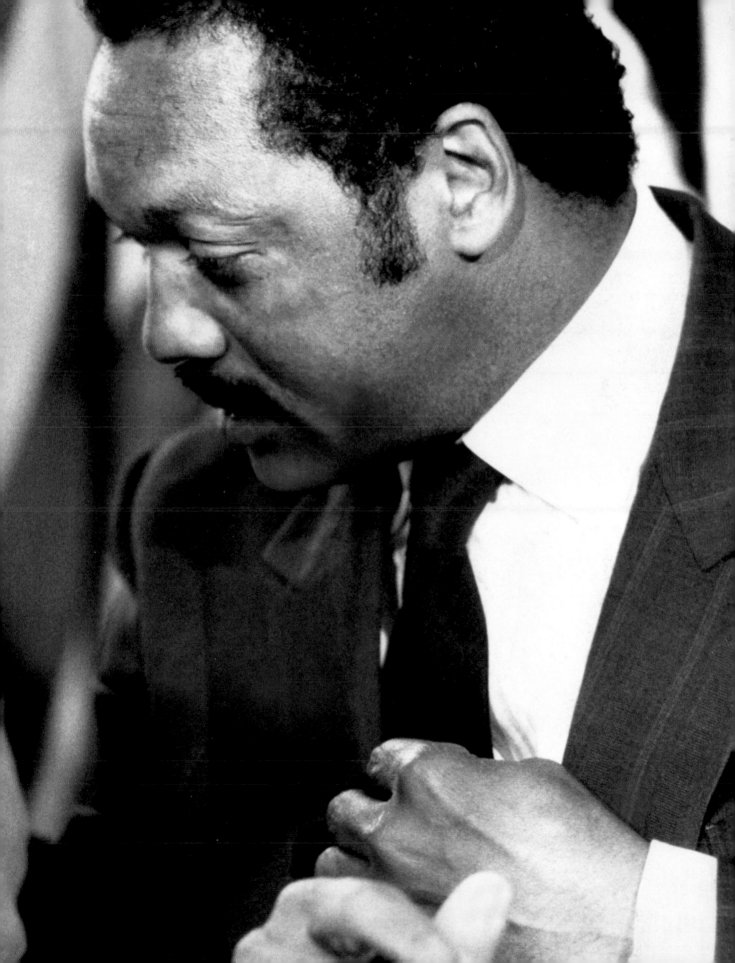

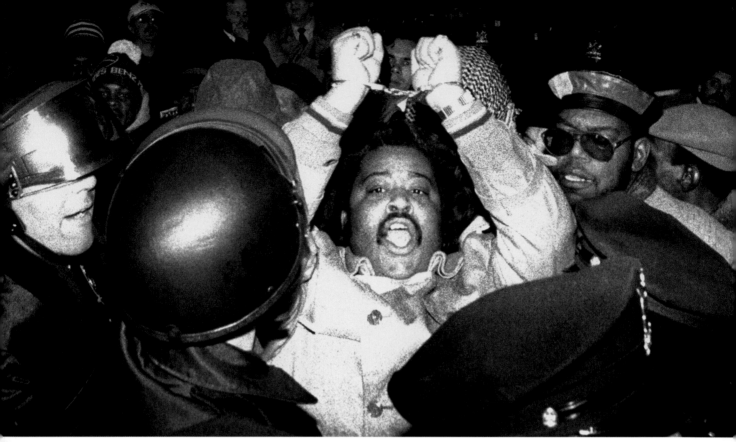

AUTHOR, AUTHOR
The Reverend Al Sharpton, getting arrested in a 1986 demonstration.
John Roca

THE ED KOCH I KNOW
BY REVEREND AL SHARPTON

My first meeting with Ed Koch was in 1978. Within his first 100 days as mayor of New York City, he had me in handcuffs. A more recent meeting with Ed Koch was quite different. The unexpected encounter in an upscale midtown Manhattan restaurant last spring ended with laughs and the sharing of stories to any and all who would listen about how Koch is now widely applauded in black New York. At my birthday celebration in 2000, he was even greeted with a standing ovation.

But let's go back to the late 1970s. New York City was racially divided and still trying to recover from its near-bankruptcy. Jimmy Carter was in the White House trying to give some sort of vision to post-Watergate America. Our new mayor was outspoken and flamboyant—as flashy as Broadway, but as neighborhood as a knish on Flatbush Avenue.

In one effortless personality, he seemed to embody all of New York, from its glitz to its grassroots, multi-layered ethnic pride.

Summer jobs had been cut. Since Koch had just challenged Carter on an issue involving Israel, we wanted him to challenge the president on allocations for federal jobs programs. On April 4, 1978 (the tenth anniversary of the assassination of Dr. Martin Luther King Jr.), three clergymen and I met with the new mayor to demand he dramatically stand up to Carter in the name of Dr. King. Expecting Koch to patronize us with a vague promise he would never keep, we were shocked when he looked us straight in the eyes and bluntly said no. He then lectured us on the budget restraints, how everyone wanted summer jobs, and how we had to deal with economic reality.

Not persuaded by his argument, we announced we would sit there in his office until he agreed to embarrass President Carter over the summer youth jobs issue. Upon hearing our ultimatum, Koch quickly got up and as he personally summoned a police officer into his office, he said, "Fine. If you won't leave, I'll have you removed."

The bewildered cop looked up and asked, "What should we do with them?" Koch looked at him and said, "Arrest them and I'll sign the complaint." We were handcuffed and walked past the waiting City Hall press corps.

And so began years of confrontation. From police brutality cases like Michael Stewart and Eleanor Bumpurs to racial violence like Yusef Hawkins in Bensonhurst, Michael Griffith in Howard Beach and the subway shooting of four black youth by Bernie Goetz, the city was battered by one racial conflict after another.

At the same time, traditional liberals began redefining their relationship with the African American and Latino community. But, more importantly, we began to redefine our relationship with them. The focus of our movement shifted from shared decency to shared power. We didn't just want access anymore. We wanted power. We wanted to make decisions, to control budgets.

Blacks were electing mayors in Cleveland, Atlanta, Philadelphia, Los Angeles, and even in Chicago in 1983. In 1984, a controversial activist preacher without a church (not me, that would come 20 years later) named Jesse Jackson ran for the Democratic nomination for president. His run energized black New Yorkers to run for district attorney, borough president, and, ultimately, mayor. This surge of empowerment coupled with the surge in racial incidents provided an incredibly volatile backdrop for Koch's 12 years in office.

Hizzoner's sarcasm and straightforwardness became offensive and seemed inflexible. His hardened views and firm beliefs seemed arrogant. We all were yelling at each other. But we'd all stopped listening to each other. Years later, when the smoke cleared and our need to realize our potential was fulfilled, we were able to look back with some detachment and a sober view.

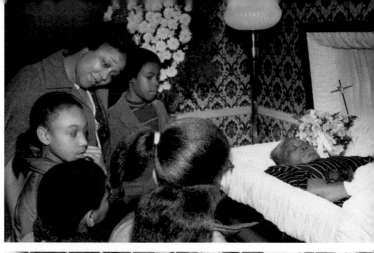

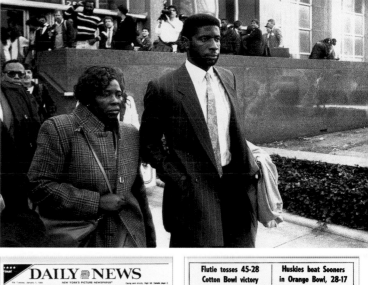

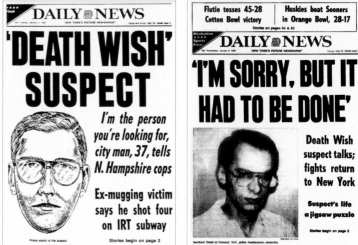

Top: ELEANOR BUMPURS
Daughter Mary Bumpurs and grandchildren say farewell to a woman slain by police officers in 1984.
Tom Monaster

Center: MICHAEL GRIFFITH
Mother and brother of Michael Griffith, who was killed by a car in 1986 while fleeing a white mob in the Howard Beach section of Queens, leaving Queens courthouse during 1987 trial.
Bill Turnbull

Bottom: SUBWAY GUNMAN
When Bernard Goetz opened fire on the subway, shooting four young black men he claimed were trying to rob him, racial tensions spiked.

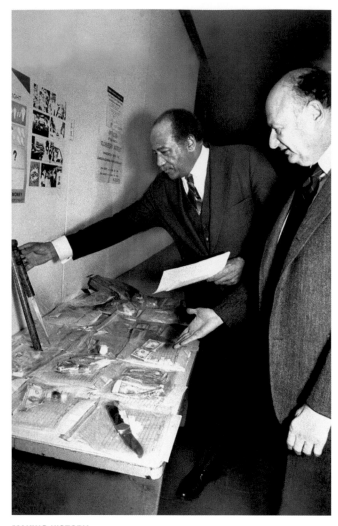

MAKING HISTORY
Koch and Benjamin Ward inspect drug bust evidence in 1984. Koch had named Ward the city's first black police commissioner.
Mel Finkelstein

Over time, we began to realize that we were not as anti-Koch as pro-ourselves. Don't get me wrong, we vehemently disagreed with some of his policies and positions, but we were far more motivated by our desire to participate in the destiny of this city. We were tired of serving the table of city leaders. We wanted a seat at the table, at the head of the table, if possible.

As 1989 began, the mayoral contest was in the front of every mind and on the tip of every tongue. The heightened tensions between Mayor Koch and the black community were at a fever pitch. David Dinkins, the Manhattan borough president, had a long civil rights, anti–South African apartheid history. His style was mild-mannered and mild-spoken, and it caused some in the activist movement to feel he was too weak or less than committed.

I have known Dinkins since I was a teenager. In fact, he was the lawyer who incorporated my National Youth Movement, Inc. group when I was 16 years old. Dinkins also was very inclusive, and had worked hard in all communities throughout his years of public service.

Koch, on the other hand, despite his hostile-to-contentious relationship with many of us, was not without support in the black community. Many leading ministers and black and Latino elected officials openly supported him. They pointed to his quiet work in our communities. And they were openly proud of his appointing the city's first black police commissioner, Benjamin Ward. We in the movement community, however, saw Ward's appointment as symbolic at best, since Ward's tenure led to no police reforms and did not reduce complaints of bad policing in our neighborhoods.

It all came to a head in August when Yusef Hawkins, a 16-year-old black man, was killed by a white mob in the Bensonhurst section of Brooklyn because of the color of his skin. We had known of the racial attitudes of many in Bensonhurst for some time, and it was an unspoken reality that blacks were not welcome in some New York City neighborhoods.

I remember as I preached Yusef's eulogy (Koch, Dinkins, and Rudy Giuliani were in attendance), I said, "We don't know who shot Yusef, but we do know who loaded the gun. A city silent about racism helped to load that gun." There were some who attempted to say Yusef's death was a mistaken love-triangle disagreement. We knew that was false. We knew race was at the center of this murder.

We decided to march down the main street in Bensonhurst to call on the neighbors to turn in members of the mob who killed Yusef. We also knew the racists in the neighborhood would show the world how race, not romance, was the issue in Yusef Hawkins' death.

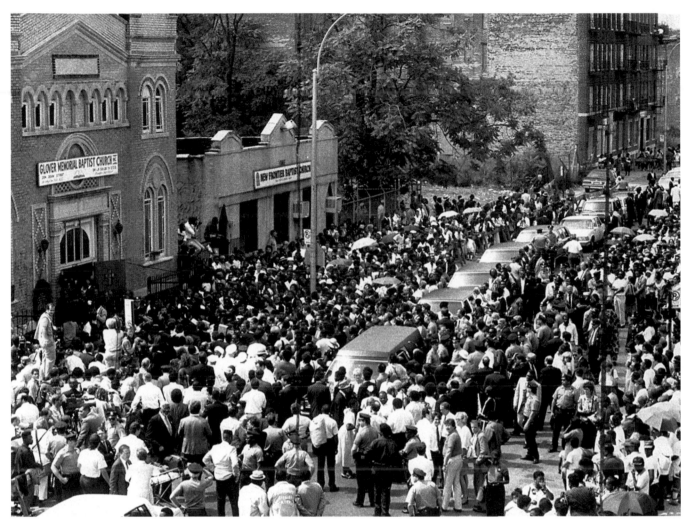

FED UP
The Yusef Hawkins funeral attracts thousands, less than two weeks before the election. Outrage over the teen's murder helped propel David Dinkins to victory over Koch in the 1989 Democratic primary.
Robert Rosamilio

I shall never forget that first Saturday march. We brought out several hundred marchers, but we were met by an even larger crowd of hecklers and haters. People threw watermelons at us and hurled racial insults. It was the only march in my life where I thought I would not live to see the end. The reaction of the nation was shock. Many could not believe what they saw on the evening news.

Dinkins wisely condemned the racists. Koch unwisely said the marchers were provocative. Though Koch probably wanted to see less chance of confrontation, his reprimand came off as blaming the victim—rather than denouncing the obvious bigots. I immediately announced we would march in Bensonhurst every Saturday until arrests were made.

Koch chided me publicly, saying I was increasing tensions. The marches and the racist reaction to the marchers galvanized blacks, Latinos, and sympathetic whites to vote in big numbers in the September primaries just days away that year. I played no official role in the Dinkins campaign, but I am certain our marches and how we were treated had the unintended effect of creating a backlash at the ballot box against Ed Koch—and boosting turnout for Dinkins, helping him to defeat Koch for the Democratic nomination. Indeed, Dinkins' victory owed much to the fact that many New Yorkers viewed him as a racial healer.

Nevertheless, the climate of racial division and police confrontation continued when Koch left

office in 1989 and Dinkins replaced him. There were new realities to deal with, and in my case, a narrow miss. In January of 1991, as we were preparing for another Saturday march in Bensonhurst, this time over the light sentences given to two of those involved in Yusef's murder, a white man named Michael Riccardi broke through the police security zone and stabbed me in the chest.

And as New York under Mayor Dinkins moved, after only one term, into the New York of Mayor Rudy Giuliani, we had to deal with new scenarios and a new mayor.

But Ed Koch would not go quietly into history. He would not fit neatly as our 1980s poster mayor of inflexibility. By the mid-1990s, I found myself sitting with him and Professor Charles Ogletree of Harvard University arguing in favor of a "second chance" for non-violent rehabilitated drug felons. I found myself in 2005 listening to him arguing for reparations for blacks in Tulsa, Oklahoma who had suffered horribly in that city's 1921 race riot and massacre.

Koch kept speaking out. He kept taking un-popular stands. And because we knew him, we knew he meant what he said. Koch was like the uncle we ran away from in junior high school, but who we later sought out after college. Someone steady. Someone stable. Someone who would tell you how he really felt.

More than 2,000 people filled Canaan Baptist Church for my 46th Birthday Rally/Gala on October 3, 2000. Many black leaders, celebrities, and entrepreneurs spoke and/or performed. And, without anyone's knowledge, I invited Ed Koch to join the celebration.

I didn't know how the crowd would react. I didn't know if they had come to the same conclusion I had. That I could disagree with him but respect him for backing some issues of importance to me that he did not have to speak on at all.

Suddenly, the side door of the pulpit swung open and to everyone's surprise in walked Ed Koch.

I hurriedly jumped up to prepare to quiet what I thought would be a jeering, taunting crowd. After all, most of the audience had joined me in marching against him and had worn "Dump Koch" buttons. Some of us had even spent nights in city jails for protesting him. Not this night. To my surprise—no, my utter shock—it seemed that all 2,000 people spontaneously jumped up and cheered wildly at the presence of Ed Koch.

Before I could recover, the 105th mayor of the city of New York stepped to the microphone and asked the huge gathering, "Do you miss me?" They roared back "YES!"

I must admit I still don't know what I hold more against Ed Koch, having me handcuffed and jailed in 1978 or upstaging me at my own birthday party in 2000.

In many ways, the saga of our sometimes-contentious relationship mirrored race in the city, where it was and what it has become. I've liked, disliked, admired, despised, marched against, and stood up for Ed Koch over the last 27 years, as he has for me. During this time, maybe we sensed that we were dance partners to music we could not control, but had to keep up with.

Through it all, I respected Koch then as I do now because I never believed him to be a phony or disingenuous. Even if his positions or statements were not popular, he said what he felt and did what he believed to be right—even if I felt it was totally wrong. That is a rare trait in public servants. That is why Ed Koch is a rare man and was a rare mayor.

Reverend Al Sharpton has run for elective office four times, most recently for the Democratic nomination for president in 2004. He is currently the President of the National Action Network and is working on television and radio projects.

MORE TENSION
Front page captures marchers' mood after Michael Griffith was killed.

~~LITTLE~~ BOY ~~LOVED~~

Mexico inferno victim finds savior in the Bronx
Story on page 5

DAILY ◉ NEWS

$1.00 NEW YORK'S PICTURE NEWSPAPER® Sunday, December 28, 1986

'WE SHALL OVERCOME'

Arm-in-arm, some singing the civil rights anthem "We Shall Overcome," demonstrators parade through the streets of Howard Beach, Queens, where black construction worker Michael Griffith was killed fleeing an attack by white youths. Marchers endured some heckling by residents. **See page 3**

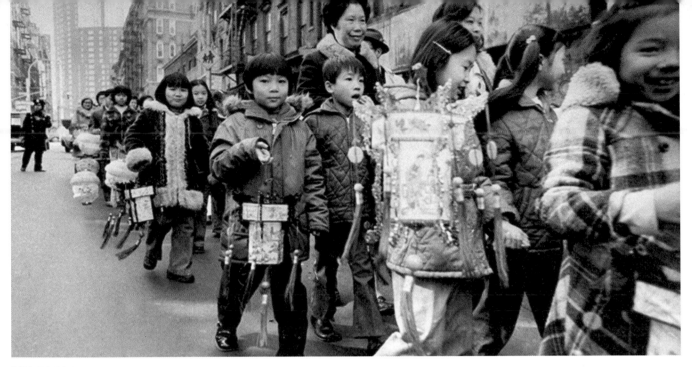

A CHANGING CITY
BY JOHN MOLLENKOPF

Looking back 30 years, it is hard to believe the 1970s were a near-death experience for New York City. Today, the city's population and job base are growing, incomes are rising, and housing and commercial real estate markets are robust. Conditions were exactly the opposite leading up to the election of Edward I. Koch in November, 1977. During that decade, the white population engaged in a massive net outflow, the overall city population declined, manufacturing employment plummeted, and the city's economy contracted.

Some observers reasonably concluded that New York might be joining other old cities like Philadelphia, Cleveland, Detroit, and St. Louis in permanent decline. Yet only New York and Boston among the nation's ten largest eastern cities grew in the subsequent decades, and New York grew fastest. In a bleak time, perhaps its bleakest, the city's residents managed to reinvent it.

The social and economic forces that swept through New York during the 1970s began to take form after World War II. During the war, the Brooklyn Navy Yard, the Brooklyn Army Terminal, and the port played key roles in supplying materiel for the European theater, helping the industrial and transportation sectors of the city economy to recover from the Depression. In 1950, despite the city's long status as the nation's biggest financial market and corporate headquarters complex, most employed people living in New York City were white, male blue collar workers. Of the 3.7 million workers living in the city, fully 1.1 million were white males employed in manufacturing, transportation, communications, utilities, or wholesale trade. Only a third that number of white men worked in finance, insurance, real estate, or the professional services. The city had the highest share of the nation's manufacturing jobs it would ever have and its

population had grown to 8.7 million. Seven out of eight of these residents were whites, of whom three out of four had a foreign-born parent. The 1950 census thus marked New York's pinnacle as an industrial giant built by the working hands of white immigrants and their adult children.

This pattern began to unravel during the 1950s and 1960s. The rising incomes of the city's white ethnic working class led many to move to the suburbs, along with the industrial and warehousing firms that had outgrown the cramped spaces of the

Top: NEW NEW YORK
Upper Manhattan has taken on a Dominican flavor, especially the Washington Heights area. Looking north on Broadway, at 150th Street, in 1986.
Jack Smith

Bottom: ABANDONED
Gutted houses in the South Bronx reflect the worst of times in some changing neighborhoods.
Clarence Davis

city. In 1962, the Port Authority of New York and New Jersey opened new container facilities in Port Elizabeth in New Jersey, with a direct rail connection to the rest of the continent—causing most port activities to shift away from Manhattan and Brooklyn docks. Within the city, corporate office buildings rose along Madison Avenue in east Midtown, in the new part of Rockefeller Center west of Sixth Avenue, and in lower Manhattan, culminating with the completion of the World Trade Center in 1972.

As white New Yorkers departed, the city's minority population grew steadily as African Americans and Puerto Ricans left the restricted opportunities of the South or the island for jobs in the new service sector and the declining industrial sectors in New York City. The formerly Italian East Harlem and Bushwick neighborhoods became increasingly Puerto Rican. After 1938, the A Train provided blacks with an avenue to move from Harlem to Central Brooklyn. As the city's predominant economic function gradually shifted from producing goods to producing services, its resident population shifted from descendants of 19th-century white immigrants to the domestic non-white migrants of the post-war period. Reflecting the city's historical role as a hub for international trade, it also witnessed the first signs of renewed international migration with a slightly higher share of foreign-born residents in 1970 than 1950. While most were born in Italy, Ireland, and Eastern Europe, new communities of Dominicans, Cubans, South Americans, West Indians, and Chinese were beginning to form.

The steady prosperity of the 1950s and 1960s masked the gradual decline of blue collar jobs and the white population. Indeed, New York experienced strong economic growth and low unemployment in the 1960s and reached a high point in employment and output in 1969. The social changes were less easily masked. By 1970, the city's population had already fallen by 9 percent since 1950 to less than 8 million, and its employed residents had fallen by one-fifth, to less than 3 million. Whites still made up two-thirds of the residents, and even more of its

voting-age citizens, but accounted for only half of those under 18. Almost one in five residents of the city were African Americans and one in ten were members of the largely Puerto Rican–Hispanic population. The city still had fewer than 100,000 Asians.

While the number of white men holding blue collar jobs had fallen by half since 1950, the number of employed women grew, as did the number working in finance, the professions, and social services. Blacks and Hispanics began to fill lower-level blue collar jobs in the declining industries being vacated by whites as well as an increasing number of lower-level service jobs.

These demographic trends had marked political implications. As significant minority communities, particularly African Americans, emerged in New York City, they began making strong demands to tear down the barriers that hindered their entry into decent jobs and political offices. Under Mayor John V. Lindsay, New York used federal Great Society initiatives to establish a host of new social service programs to serve, and provide jobs, in response to these demands. From 1965 through 1973, city government and non-profit social service employment grew steadily, fueled in part by federal aid. But the process of absorbing growing minority populations into the city's labor force and housing stock was not smooth. Conflict emerged around the police department's Civilian Complaint Review Board, the community control of schools, school integration, and the building of subsidized housing in white neighborhoods. The divisions within the Democratic party between white ethnic groups that had characterized the 1950s and 1960s—particularly between white Catholics and the more reform-minded Jews—began to fade in light of the fact that the white population was diminishing in absolute as well as relative terms.

If inter-group tensions gathered underneath a surface of economic prosperity in the 1950s and 1960s, the 1970s verged on an economic, social, and political disaster for New York City. Deeply affected by two national recessions, the city's economy went into a steady slide between 1969 and

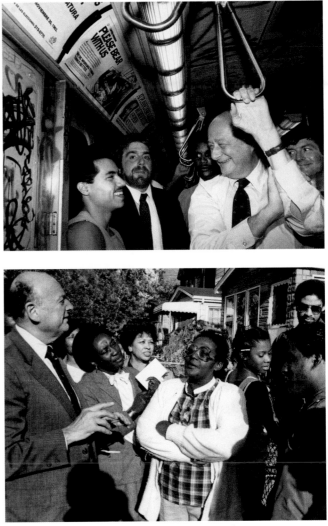

WORLD CAPITAL
New York has always been a city of immigrants, but the makeup of the city changed as many whites left for suburbs and were replaced by non-whites. Koch makes the rounds to visit some new New Yorkers, who include Dominicans, Cubans, South Americans, West Indians, and Chinese.

Top: Chatting with Joey Valdez on the R train in Brooklyn.
Harry Hamburg
Bottom: Ed Koch giving, and getting, advice in Jamaica, Queens.
Anthony Pescatore

1976. From a high point of 3.8 million jobs in 1969, employment in the city fell by 610,000 jobs, or 16 percent, over those seven years, while payroll fell even faster. Not since the Great Depression had the city experienced such an economic blow. As the job base and earnings contracted, employment fell among New York City residents, especially blacks and Hispanics.

With the decline came rising poverty, increasing difficulty in meeting basic family needs like paying rent, and housing abandonment by

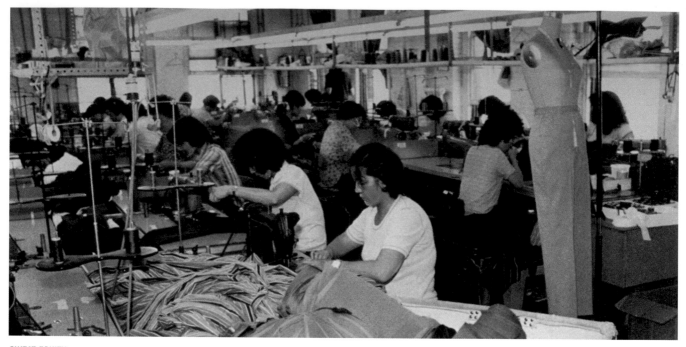

SWEAT EQUITY
Garment factories, such as this one in Chinatown in 1983, provide entry-level jobs for many immigrants.
Charles Frattini

rental property owners unable to make a go of it. Whole sections of the Bronx burned out, many industrial areas of the city came to look like an urban wasteland, and the pace of racial and ethnic turnover picked up in many neighborhoods. All of this crystallized in the blackout and widespread looting of July, 1977. Economic contraction also diminished city revenues. The municipal government nearly defaulted on its debts and was forced to make severe budget reductions, resulting in many service cuts. It was hardly surprising that many of those who could leave the five boroughs in search of greater opportunity and a better life did so.

As it took office in January, 1978, the Koch administration thus faced a dire economic and demographic environment. Between 1970 and 1980, the city's population declined from 7.9 to 7.1 million. Behind these overall numbers stood large differences among the racial groups. The net decline of the white population was almost 1.4 million people. If it had not been for the growing black, Hispanic, and Asian populations, fed by the flow of immigrants into the city after 1965, the contraction of the city's population would have been even greater. At the end of the decade, non-Hispanic

whites made up only 52 percent of the city's population, although they still comprised 62 percent of its voting-age citizens.

The one-quarter reduction of the city's white population during the 1970s played out in different ways across the city's traditionally white ethnic neighborhoods. Whites regrouped in some areas with the strongest concentrations and institutions, such as the central and southern parts of Staten Island, Bay Ridge and Bensonhurst in Brooklyn, or Middle Village in Queens. But many other traditionally white neighborhoods rapidly became minority communities. Flatbush, Brooklyn, where Woody Allen and Barbara Streisand grew up in the 1950s, had become an Afro-Caribbean and African American neighborhood by 1980. While this represented upward mobility and better housing for the new residents, whites were far less sanguine about what had happened to their old neighborhoods. The level of conflict along the shifting racial boundary lines was quite high.

The demographic and economic divisions that disturbed the city during the 1970s set the stage for the Koch administration. On the electoral side, Mayor Lindsay had twice won office by 43 percent

over Jewish and Catholic old-school Democrats and Republican opponents. In 1973, Mayor Abe Beame won in another divided field that included two Italian American Catholics and a Jewish reformer running on the Liberal ballot. In 1977, Ed Koch won the primaries and general election by defeating an Italian American, Mario Cuomo, who ran first as a Democrat and then on the Liberal ballot line. Substantial support from African American voters helped Koch win.

After that election, however, the Koch administration, staffed in considerable part by individuals who came into public service during the Lindsay administration, decided to reshape its electoral basis by forging a coalition between Jews and Catholics, crossing the line that had previously been the main political division within the electorate. Both groups were concerned that their civic traditions and neighborhoods were coming undone under the twin pressures of economic decline and racial transition. Many African American voters felt excluded from this coalition. But Mayor Koch had established an electoral pattern in 1981 and 1985 that persisted through every succeeding mayoral contest to date.

To the extent that municipal policies regarding restraining budgets, reducing tax burdens, achieving new efficiencies, and focusing on economic development can hope to produce positive trends in employment and income, the Koch administration's policies met with success in the basic trends between 1978 and 1989. It came into office with a steady expansion of employment, which reached a new peak of 3.6 million in 1989, with total wages climbing from $48 billion to $114 billion.

Given restraints on municipal spending increases, economic growth generated growing revenues and allowed the city government to balance its books. More generally, the economic recovery and the steady increase of new immigrants reversed the population decline of the previous four decades. Between 1980 and 1990, the city rebounded to 7.3 million people. By 2000, it had climbed above 8 million. Though the white

RUST BELT
Like many northern cities, New York lost much of the manufacturing base that provided jobs and made the economy hum. Here is the old Sohmer piano factory building in Long Island City in 1982.
Mary DiBiase

population continued to decline—with native-born whites accounting for only a quarter of the city's population in 2000—the native black population also declined, as immigration not only drove the Hispanic and Asian populations upward, but reshaped the white and black populations.

Though the Koch administration left New York in 1990 as a place where the white population continued to decline and poverty rates remained stubbornly high, it was also a place where the increasingly diverse population was becoming better off on average.

John Mollenkopf is a Distinguished Professor of Political Science and Sociology at The Graduate Center of The City University of New York and Director of its Center for Urban Research. He has authored or edited a dozen books on urban politics and policy, including the forthcoming *Contentious City: The Politics of Recovery in New York City* (Russell Sage Foundation).

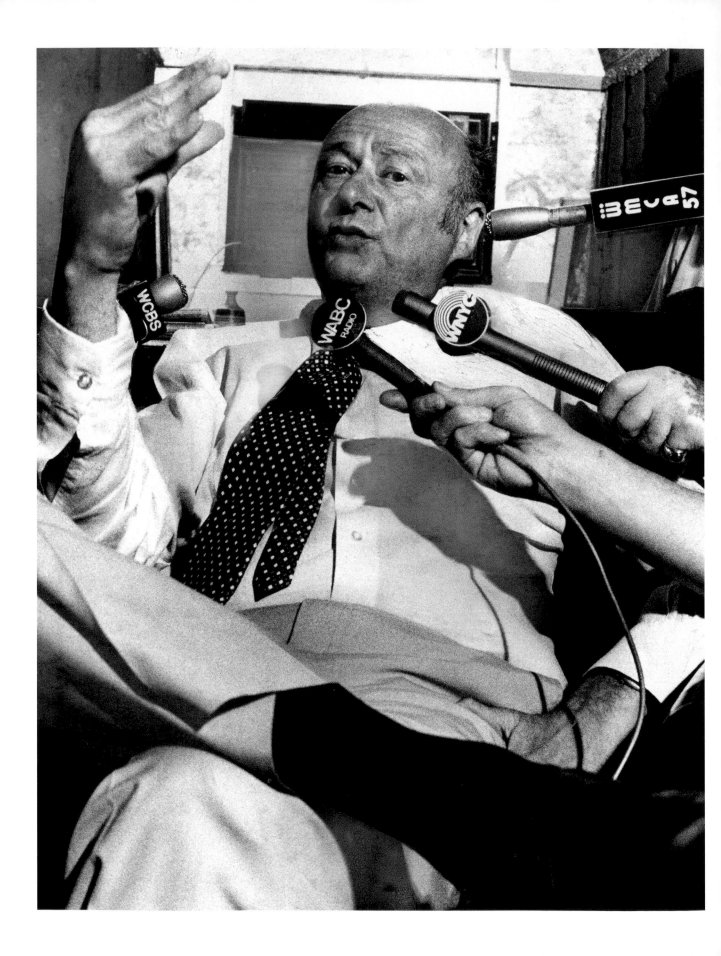

A MARRIAGE MADE IN MANHATTAN
BY EVAN CORNOG

Ed Koch and the press, Brooklyn and baseball, East Side and West Side, Uptown and Down—each of these pairs is quintessentially New York, and each is both highly complementary and in profound tension. To understand Ed Koch's successes (and failures) as mayor, one must come to terms with the relationship he had with the press, a relationship that the mayor himself saw as vital to his political success.

My take on this will of necessity be personal—I worked in Koch's press office for three and a half years, the last year and a half as his press secretary. I joined his City Hall staff in March, 1980, about halfway through his first term. The city was still deeply mired in the fiscal crisis that had caused Gerald Ford to tell the city to "Drop Dead" (in the characterization of the *Daily News*), and there was little glamour to be found, either in the mayoralty or the city. Graffiti covered the walls and windows of subway cars, the city's infrastructure was sagging where it was not breaking, and musings on the death of the city were found in leading magazines and in popular films of the era (*Taxi Driver*, *Escape from New York*, *The Warriors*). The first mayoral event I got to go to with the mayor was a groundbreaking for a new sewer in the Bronx. In prior decades, mayors saved their luster for new schools and libraries—which is one reason the city was falling apart. Ed was honest enough to tell the public that, and straightforward enough to back this idea with his presence.

So perhaps Ed Koch was the perfect personification of the city for that time—a man who had made it to the office through grit and drive, and through his ability to express the views of city residents in terms and cadences that instantly rang

true for New Yorkers. In a city that circumstances seemed to be constantly demanding apologies from, Ed Koch was not in the mood to beg pardon. Critics—of the mayor, his policies, or his beloved city—were excoriated as "wackos," and their views derided as "ridiculous." In a city where the pace is fast, and where even before the birth of the 24-hour news cycle, the appetite of local TV news and all-news radio for quick sound bites was insatiable, Ed's colorful language and in-your-face attitude made for great entertainment.

And if the news media needed Ed, the mayor certainly knew he needed it. Even as a member of Congress, Ed was well-attuned to the media. (One staffer from those days told me how Ed used to pick up the great weight of the Sunday *New York Times* on a Saturday night and could find a mention of himself within 30 seconds.) As mayor, he was exceedingly eager to satisfy their wants.

The mayor, of course, held press conferences on a regular basis, usually called to announce a specific measure. But the hunger for news from the City Hall reporters stationed in Room 9 could not be sated, so we instituted a daily event I dubbed the "at-homes." Like a person of fashion in the 19th century, the mayor would be "at home" in his office to take a random grab bag of questions from reporters. The origins of this practice, though, were not as genteel as its name.

One radio reporter, whose iniquity will be shielded by anonymity, began lying in wait for the mayor outside the men's room in the west wing of City Hall. (What in another profession would be seen as indelicate, or simply rude, is viewed in journalism as enterprising.) The mayor, never one to pass by a live microphone, would comment, and the reporter would be happy. But his rivals sometimes were not. So these ambushes were transformed into at-homes, with most of Room 9 crowding into the mayor's office to question him on the issue

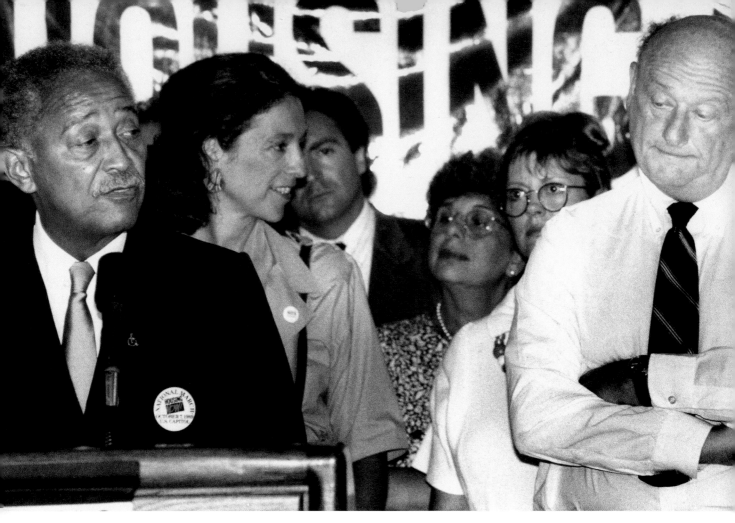

NOT HAPPY
Even with the cameras on him, Koch was never very good at hiding his emotions. He shows his frustration at a 1989 press conference about the homeless with David Dinkins and Ruth Messinger, two of his most persistent critics.
Clarence Davis

du jour, whether it had anything to do with city government or not. We would usher reporters into the mayor's office, where Ed would sit in his favorite chair, in his shirtsleeves, as radio reporters targeted him with their microphones and print reporters, a little farther away, probed and jousted. Perhaps a dozen reporters would attend each session, as a small contingent of mayoral aides watched. The mayor seldom disappointed.

Ed Koch was God's gift to the slow news day, and his offhand remarks on national politics, the Middle East, or pretty much any other topic would become fodder for nightly local news and newspaper ruminations. One target was the United Nations, and his denunciations of that organization were as barbed as he could make them.

As press secretary, the calls I dreaded most were the ones that tended to come at seven o'clock Sunday morning, after he had read the papers and found some matter of international import that he wished to comment upon. Usually these "foreign desk" assignments involved taking down the mayor's remarks on the latest UN muddle or terrorist outrage, and then phoning his comments in to bored desk reporters at the wire services. The disparity between the mayor's passion and the newsmen's indifference was always a source of acute discomfort to me—the only time I really felt like a "flack."

There were other times that things got sticky, and when the mayor had decided that a newsman needed to be told off, it was hard work to restrain

him. I sometimes let dictated letters to offending reporters age in my in-box like a fine wine, hoping that Ed would cool down, and enlisting more senior advisers and friends in the effort to spike the letters. Often I succeeded in getting the letters killed, and sometimes Ed paid the price for sending them. But Ed, in general, knew best. He knew that his electoral strength depended in part on his entertainment value, and he knew that he could not accomplish the serious and real goals he had set for his mayoralty without that electoral strength.

His energetic leadership and take-no-prisoners rhetorical style won him a wide and enthusiastic following, and the national media came to pay their respects. Events like the photo shoot for the mayor's appearance on the cover of *Time*

magazine, or an appearance on *Saturday Night Live*, helped cement his position as a personality of wide-spread appeal and influence. Nor is it surprising that his post-mayoral career has included so many media engagements—as radio personality, newspaper columnist, TV judge, and advertising pitchman. Few could communicate more directly and vividly than the mayor, and this is a skill in great demand in our modern, media-saturated world.

It is a great irony of his career that this very gift was what deprived him of his loftiest aspiration, the governorship of New York State. In the fall of 1981, after his reelection as mayor to start a second term, Ed sat down with a reporter from *Playboy* magazine to do one of their famous inter-views. I sat in on the sessions, and heard Ed hold

he of course accepted with good humor.) Ed Koch had a gift for memorable phrases—and upstate Democrats remembered these phrases on primary day. He won three terms as mayor in part because of his gift for turning a phrase. But sometimes one's gifts can betray a person, and so it was, in this instance, with Ed.

But generally his vivid language and feisty character served the city well, restoring confidence as he and his administration labored to restore other parts of the ravaged city. New York turned a corner under Ed Koch—and he was never shy about telling reporters it was so.

Evan Cornog is publisher of *Columbia Journalism Review* and the author of *The Power and the Story: How the Crafted Presidential Narrative Has Determined Political Success from George Washington to George W. Bush* (Penguin Press, 2004).

CAMPAIGN GURU
David Garth, showing a TV commercial, ran Koch's mayoral races. Earlier he had helped elect John Lindsay and Hugh Carey. Later, he helped Rudolph Giuliani win City Hall.
Ed Molinari

forth on a variety of subjects. He went on in a familiar vein about his dislike of places other than New York City—a well-worn trope of his mayoralty, and one that played well in the five boroughs. Unfortunately for him, the interview came out as he was launching his campaign for governor (a race inaugurated by a *New York Post* coupon campaign, in which readers cut out and mailed coupons from the *Post* urging the mayor to run for governor). So Ed's gift for a phrase betrayed him, as upstate was derided as a place where folks drove "pickup trucks," and wore "gingham dresses" and "Sears, Roebuck suits." (On a trip on city business to Albany—dubbed "a place worse than death" in the interview—soon after he announced his candidacy, the mayor was given a brown Sears suit, which

LINE OF SUCCESSION
Koch plays host to his three predecessors in 1980 as Robert Wagner, left, Abe Beame, and John Lindsay gather for this rare photograph. The four men served a total of 36 years in City Hall, starting with Wagner in 1954 and ending with Koch in 1989.
Willie Anderson

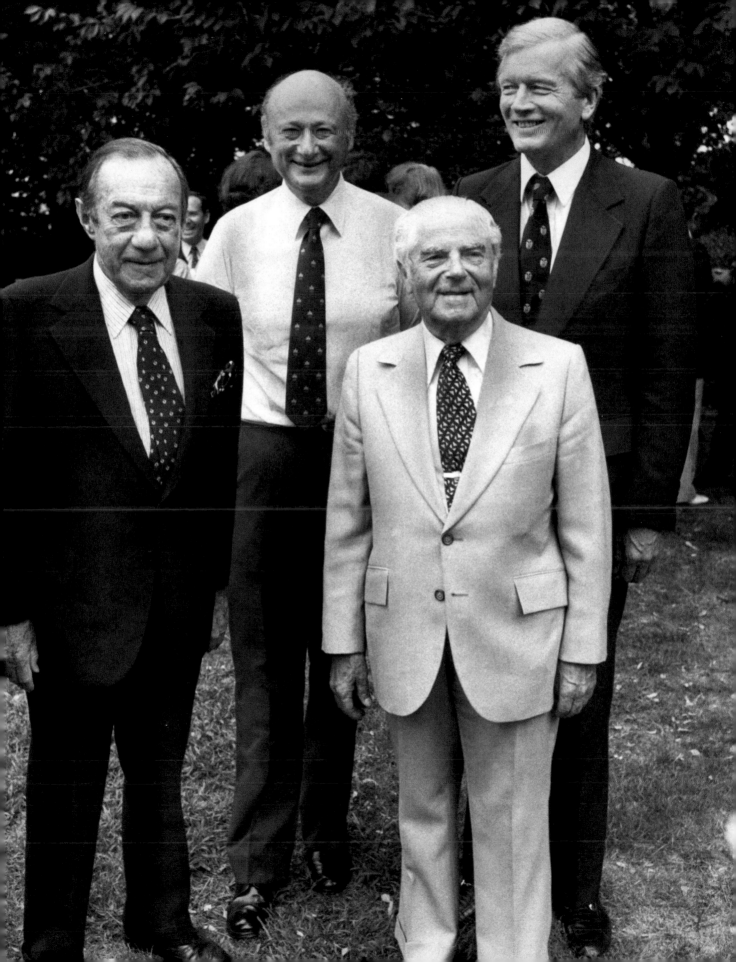

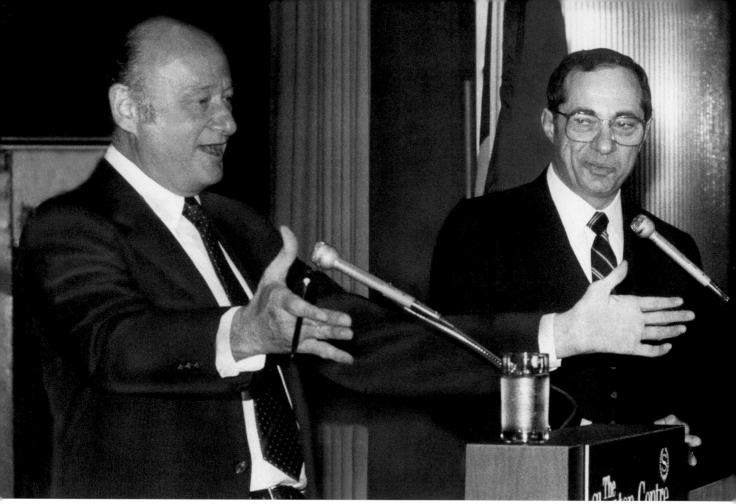

HERE THEY GO AGAIN
Five years after Koch bested Mario Cuomo for City Hall, the two men face off in the 1982 Democratic primary race for governor. In early July, the mayor gives a poor performance in their first debate, and later admits that his heart was never in the race.
Anthony Pescatore

GOVERNOR KOCH?
BY JOYCE PURNICK

It finally happened. It had to, right? After riding high as an urban Icarus, Ed Koch crashed. It was 1982—the year a jilted New York City fell a bit out of love with Ed Koch.

Not that everyone was in love with him, of course, but he sure was popular. The city's ebullient "How'm I doing?" leader won a second term in November, 1981 with an impressive 75 percent of the vote. Koch was the only mayoral candidate elected on the two major party lines after winning primaries in both parties. He graced the cover of *Time* magazine's international edition, arms outstretched in triumph.

Long before Rudolph Giuliani became America's mayor, Ed Koch was an international celebrity. And then, Koch ran for governor of New York. The very same Koch who had pledged at Israel's Western Wall that he would never seek higher office; who always complained he got the "bends" outside of his city; who liked to call living in Albany "a fate worse than death."

Everyone knows what happened. He lost, mostly from self-inflicted wounds, and found himself right back where he started—as mayor, but of a city he'd been willing to leave behind.

Since he now says he never wanted to be governor anyway—why did he do it? "Hubris," said the former mayor, 80, sitting in his law office in early 2005, reflecting on that ill-fated campaign 23 years ago.

Koch being Koch, he said more. "It was a lark. I don't want to denigrate the race but it was a lark," he explained. "And it was a challenge. If I had to resurrect a reason in my head, it was a challenge. No New York City mayor had, in the modern era, ever been governor." In other words, like so many in the public eye who seem to have it all, he wanted more.

The 1982 campaign began in a Koch-typical loud way. In January, he'd been vacationing in Spain with some friends, including David Garth, his political media adviser. The vacation was pure pleasure—no politics, Koch insists to this day.

But while Ed was away, Rupert played.

Rupert Murdoch, the Australian-born publisher of the *New York Post*, had become a political power in his new city by using his newspaper to champion Congressman Ed Koch's election as mayor in 1977.

Five years later, Murdoch set his sights on Albany, where the incumbent Democratic governor, Hugh Carey, had decided not to seek reelection. The *Post* began a campaign to draft Koch for governor, complete with mail-in coupons, and by the time Koch returned to New York from Spain in late January, he was greeted by a large group of reporters at JFK International Airport.

Was he running for governor? He did not say yes. He did not say no. 28 days later, on February 22, he announced his candidacy.

In the interim, quite a debate had raged among Koch insiders. Close friends, including Dan Wolf and Allen Schwartz, urged him to go for it. Political advisers, led by Garth and his partner, Maureen Connelly, urged the opposite. Schwartz, the former mayor's first corporation counsel—the city's top lawyer—had even kicked around the idea shortly after the mayor's reelection, recalls a member of the Koch inner circle. He contended then, and again after the *Post*'s coupon drive, that by having more

direct control over state finances, a Governor Koch could best help the city.

Garth and Connelly, Koch's first press secretary, lobbied vehemently against the idea. "It wasn't the right job for him," Ms. Connolly said recently. "Dealing with the legislature was not his strong suit. He'd be in Albany, and he was always miserable when he was not in the city. We were saying, 'You're not going to be happy doing it. You love your job.'"

But Koch was hooked—and supremely confident. The very prospect of his candidacy narrowed the Democratic field to one—his vanquished rival from the 1977 mayoral campaign, Lieutenant Governor Mario Cuomo. But history was not to repeat itself. This time, the Koch campaign fumbled from the beginning.

Actually, it fumbled *before* the beginning. About a month after his November reelection, Koch was late for a Saturday meeting of advisers at Gracie Mansion. Rushing in, he explained he'd just completed a series of interviews with a writer for *Playboy* magazine. "Ed said, 'no problem, absolutely no problem, nothing to worry about,'" one participant recalls today.

Not quite. Advance copies of the *Playboy* article began to circulate a mere two days after Koch announced his candidacy on February 22. It contained one bombshell after another.

In it, Koch called life in the suburbs "sterile." He called rural living "a joke." He spoke derisively of "wasting time in a pickup truck," of driving everywhere. "When you have to drive 20 miles to buy a gingham dress or a Sears, Roebuck suit? This rural America thing—I'm telling you, it's a joke." As he had before, he ridiculed Carol Bellamy, the city official who would succeed him if he became governor.

Koch had given *Playboy* a candid, revealing, and arrogant interview—the kind only a secure politician with no immediate plans to run for another office would even contemplate.

The article proved toxic. Koch maintains to this day that he simply had not remembered what he'd told the *Playboy* interviewer when he was weighing whether to run. Not that he would have let it stop him, he insists today.

Others remember it differently, but Koch contends that he actually knew about the tone of the article before he announced his candidacy. He says that while he didn't see the piece itself, someone had leaked its outlines to him.

"There is no question I knew it was coming out, no question I knew it would create problems. But I thought I could overcome them." Koch says he never seriously considered canceling his announcement. "We were too far along, too many people had committed themselves." Especially Koch himself.

After the story went public, headlines blaring, the nascent candidate tried to keep his reaction light—insisting he'd been speaking "jocularly," that he'd been defending the city.

But the damage was done. Koch's internal polls showed that by April, when he began statewide campaigning, he had gone from 37 points ahead of all prospective candidates (before he was even a candidate himself) to only ten points ahead of Cuomo.

Today, the former mayor does not think "that stupid article" angered upstate New Yorkers—"I think they thought it was hilarious." As he prefers to see it, the interview underscored his city-centric identity, reinforcing suburban and rural fears that as Governor Koch, he would help the city at everyone else's expense.

The damaging *Playboy* interview foreshadowed the tone of the Koch campaign, which never established itself. As a confident Cuomo gained traction, Koch seemed off-balance. Ultimately Cuomo won the Democratic primary by a margin of 52 to 48, and then he soundly defeated his Republican opponent Lewis Lehrman.

In his book *Mayor* (Simon & Schuster, 1984), Koch blamed defeat on a number of factors, including his media and non-media campaigns. He gave himself a bit of blame, too. Beth Fallon, a *Daily News* columnist at the time, wrote that the real problem was Koch—that his heart was never in the race.

Today, he says he agrees. "That I didn't have my heart in it is I think a fair reading. I didn't really want to be governor. They don't have good Chinese restaurants up there. And on the merits, I would've been devastated because you cannot deal with the state legislature."

But Cuomo is convinced that Koch lost "because he didn't have a rationale," he said recently. "It wasn't just hubris. He worked hard, spent a lot of money. But he did not have a rationale for running. He didn't really want to do it." And, Cuomo added, voters accepted his two-fer argument: "I wore two buttons—Koch for Mayor, Cuomo for Governor."

Koch remains sunny, at least publicly, about the race. If he had it to do over again? "I wouldn't do it. Do I regret it? No. I saw New York State like nobody else would ever see it. It was fun. I look back on it as part of my life nobody else will ever have. People will be able to repeat the lines about the gingham dresses, the pick-up trucks. It's fun."

Fun? That's a stretch, even for the insistently optimistic Ed Koch. For the rest of us, it is impossible to look back at the campaign of 1982 without seeing it as a steep downfall for the former mayor, a humiliation for this vivid politician who had once seemed impervious to the normal vicissitudes of public life. Yes, he was still mayor. And he soundly won reelection in 1985 to a third term—even if it did turn out to be a troubled one.

But Koch's aging love affair with significant segments of his city continued. As in a patched-up marriage, it was oh-so-nice to be back together again. But it was never quite the same.

Joyce Purnick, author of the *New York Times*' Metro Matters column, has written about New York politics for over 30 years, and about Ed Koch since his 1977 mayoral race. She was a member of the *Times* Editorial Board, and the paper's City Hall Bureau Chief.

UPSET IN THE MAKING
Top: Koch and Cuomo are all business in a debate with TV newsman Gabe Pressman.
Pat Carroll
Bottom: Cuomo and wife Matilda get the last laugh when votes are counted.
John Roca

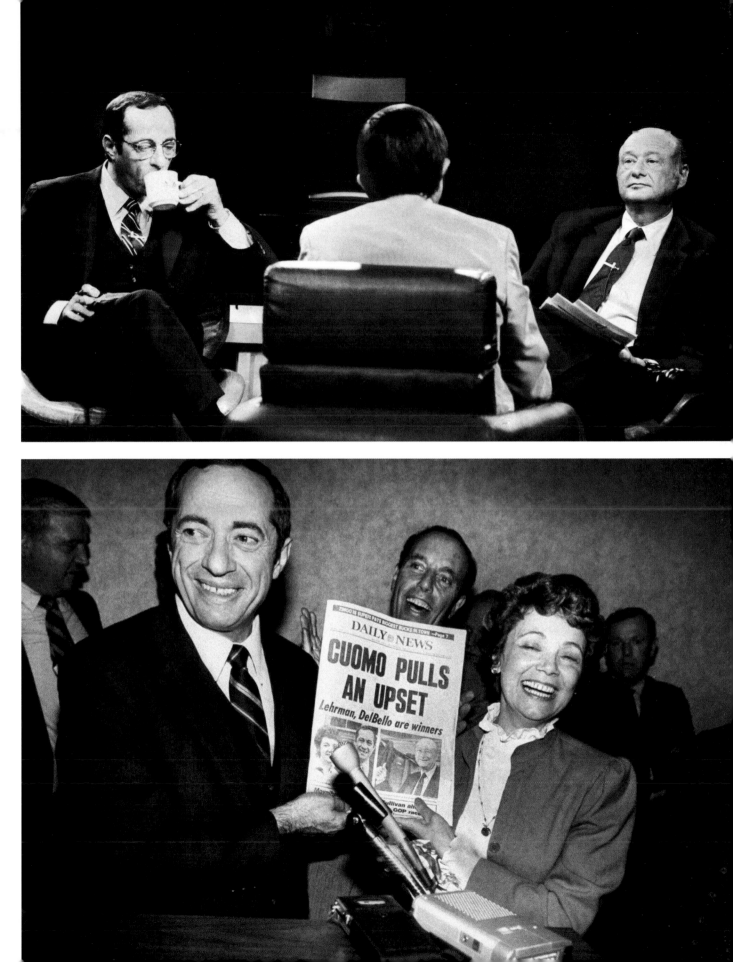

CROSSROADS COMEBACK
Times Square turns 100 in April, 2004. Its glitzy, tourist-friendly revival is one of the great urban success stories in America.
Mike Albans

TRANSFORMING TIMES SQUARE BY CARL WEISBROD

No other physical change in New York over the past 75 years has had as much impact on the city as has the transformation of Times Square.

The rebirth of 42nd Street and, as a consequence, the broader theater district area, has profoundly affected New York's economy, its real estate market, Manhattan's development patterns, the city's crime rate, as well as the hospitality, tourism and entertainment industries. The "new" Times Square has totally changed, for the better, New York's image in the nation and the world. And it has also influenced how hard-bitten—and frequently cynical—New Yorkers feel about their city and themselves.

Many people can claim some responsibility for this monumental achievement. After all, victory —especially one of this magnitude—has many fathers, while defeat is an orphan. Indeed, Times Square's transformation has proceeded under three governors and four mayors. But it is clear that one man—Ed Koch—deserves most of the credit. Without his leadership and commitment, the rejuvenation of Times Square would not have occurred.

When Koch became mayor in 1978, he faced many daunting challenges. Conditions in Times Square were not his top priority. After all, "cleaning up" Times Square had been the longest-running joke in New York since before World War II. Every mayor including and since Fiorello LaGuardia had tried to improve West 42nd Street and the broader area, but conditions had only gotten worse. In fact, Koch himself would get on television to advise tourists to steer clear of 42nd Street, and instead, go to more hospitable environs when visiting New York.

Since well before 1978, West 42nd Street between Broadway and Eighth Avenue was, by almost every measure, the single worst block in the city of New York. By the time Koch took office, conditions on the block were staggering. It was

dangerous—five to six serious crime complaints a day were reported on this one block alone. It was dirty—it cost the city's Sanitation Department ten times more to clean this one street than any other in Manhattan. It was depraved—the street and the surrounding environs were a magnet attracting runaway youth from around the country; socially disaffiliated people of all kinds; and under-age male prostitutes, "chickens," and the adult men, "chicken hawks," who preyed on them. It was threatening— despite having one of the city's highest pedestrian traffic counts, less than 10 percent of those who traversed the block were female.

No new building had been built on the street for 40 years. That was not a surprise. In addition to its horrible conditions, it was the center of city's commercial sex industry—25 to 30 sex-related establishments resided on this one block alone. The street was the city's de facto "combat zone." Moreover, even 42nd Street's non-sex-related businesses—fast food joints; hole-in-the-wall grocery stores that principally sold beer, condoms, and knives; and penny arcades specializing in fake IDs—provided a support system for criminals who conducted their activities across a broad swath of west Midtown.

Early in his first term, Koch set up a task force co-headed by the deputy mayor for criminal justice, Herb Sturz, and city planning commission chairman, Bob Wagner Jr. The task force developed a set of modest economic development initiatives and creative law enforcement strategies, coupled with a massive increase in police presence. At its peak, more police were assigned to 42nd Street than were stationed in a typical city precinct. Despite some successes in the broader Times Square area— particularly along Eighth Avenue (then known as the "Minnesota Strip" because so many of the

prostitutes who plied their trade here were young girls from the Midwest)—it was clear that a much bolder approach would be necessary to change West 42nd Street and Times Square.

When Koch took office, some significant projects were already underway. Manhattan Plaza, a luxury residential development on Ninth Avenue and 42nd Street, had opened in 1977 as subsidized housing for performing artists. Theater Row, consisting of several off-Broadway theaters, on 42nd Street between Ninth and Tenth Avenues, opened in 1978. And, under Koch's department of city planning, a massive rezoning of midtown Manhattan was being planned that was intended to shift development from the congested East Side to the West Side.

In this context, plans were made by Fred Papert (the force behind Theater Row), along with Helmsley-Spear, Rockefeller Center, Equitable Life, and Olympia & York—then one of the most dynamic commercial developers in North America—to create an office and entertainment theme park called the "City at 42nd Street," which would encompass the area from 41st to 43rd Street between Broadway and Eighth Avenue.

The City at 42nd Street required that the property in the proposed project area be acquired by the public from resistant owners. The only public entity with the power to acquire property quickly through eminent domain was the state's Urban Development Corporation (UDC). Under the law,

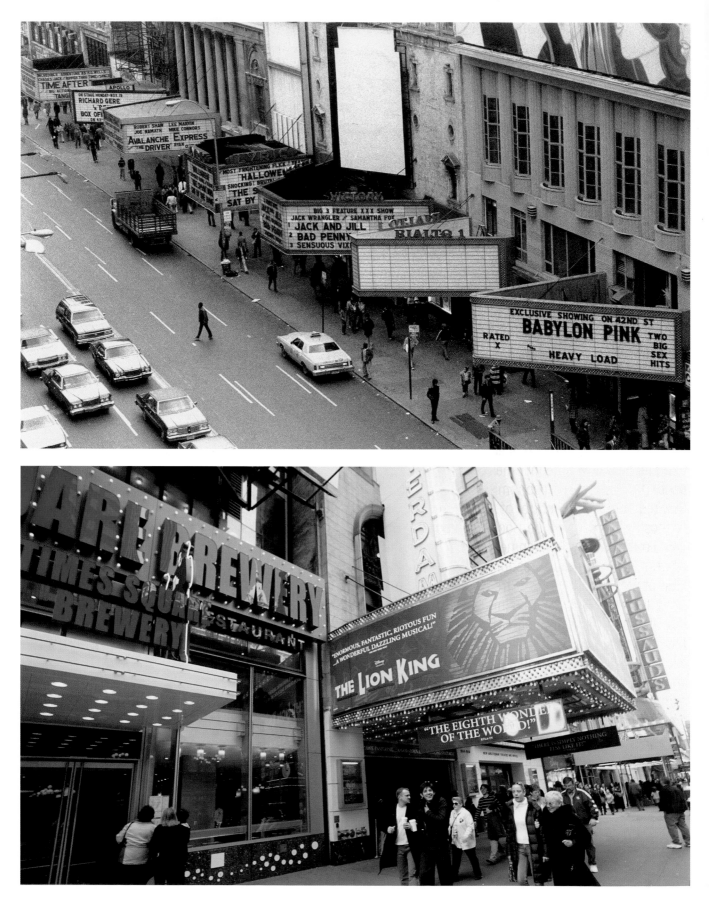

UDC could proceed without the city's approval, but as a matter of policy it wouldn't do so. The City at 42nd Street sponsors asked for Koch's support.

They didn't get it.

Koch pronounced the project "Disneyland on 42nd Street" and called for a project that was "seltzer instead of orange juice." Koch had a good feel for what New Yorkers would consider authentic. More importantly, he was unwilling to hand over 13 acres of Midtown real estate to private interests without a competitive process.

His decision was gutsy, coming just a few short years after the city's fiscal crisis, at a time when physical development was non-existent. He rejected a plan, backed by a broad cross section of the city's civic and economic establishment, which promised to restore an area of the city that had been the bane of New York mayors for half a century. It was a decision that set the tone for Koch's toughness and commitment on Times Square issues for all the years of his mayoralty.

Although Koch rejected the specifics of the City at 42nd Street, he embraced its central thesis— that significant change in Times Square would only occur through major economic development, and that required public control of 42nd Street itself. But in these early days of the Koch administration, the city didn't have the development expertise, the legal powers, or the financial resources to undertake the kind of massive effort 42nd Street required.

In 1980, Koch entered into a partnership with the UDC to redevelop the area. The city would take the lead on financial issues, UDC, through its extraordinary powers, would implement the project and both parties would be jointly responsible for planning and design. The city and UDC agreed to create a site plan and design guidelines. The original plan called for four office towers at the intersection of Broadway and Seventh Avenue and 42nd Street; a Merchandise Mart and a hotel on the western end of

the project area at 42nd Street and Eighth Avenue; and the revitalization of the historic theaters in the 42nd Street mid-block.

Koch approved a unique financial approach for the project that was a direct outgrowth of the city's fiscal problems of the mid-1970s: UDC would use its power of eminent domain to acquire the property on 42nd Street, but the private developers would directly pay for the land acquisition costs. In return, the developers would be guaranteed that they would recover costs beyond a certain amount out of project cash flow that would otherwise go to the city. This arrangement protected the city from incurring significant capital costs at a time when its access to capital markets was limited, and subject to the approval of both federal and state overseers. However, it also provided very aggressive tax incentives to developers who were prepared to take major risks and make long-term commitments.

42nd Street, 1980
Harry Hamburg

In October, 1984, the 42nd Street Plan, the development partners, and the financial scheme were unanimously approved by New York City's then governing entity, the Board of Estimate. It was a historic moment. It was the last time that all of the principals of the board, the mayor, the president of the city council, the comptroller, and the city's five borough presidents all personally attended a meeting to which each of them usually sent surrogates. It was the first time in 35 years that New York's

governor testified before the board. Senator Daniel Patrick Moynihan, who spent part of his childhood in the Times Square area (his mother owned a bar there), testified in favor of the project, as did former mayors Wagner and Beame.

It seemed like the 50-year decay of Times Square was about to change. But that was not to be —at least not yet.

From 1984 through 1989, 47 separate law-suits were brought against the project. None was successful, but each delayed implementation. There were other problems as well. A major financial partner for the office developer dropped out, to be replaced by Prudential Insurance Company. The developer of the mid-block theaters was dismissed due to an unrelated corruption scandal.

Dramatic swings in the economy, from bust to boom to bust, led critics to charge Koch with giving a sweetheart deal to developers, and the mayor responded by directing his staff to renegotiate aspects of the financial arrangement; two of the designated developers were forced to drop out of the project, to be replaced by others. Architectural critics were dismissive of the office buildings designs, and some were redesigned as a result.

Throughout this period, Koch's commitment to the project, when other elected officials were either in hiding or had switched from being supporters to opponents, was unwavering. While always prepared to make tactical modifications to accommodate changing conditions, Koch remained totally focused on the project's implementation.

In April, 1990, ten years after Koch dismissed the City at 42nd Street and less than four months after Koch left office, UDC finally took title, through eminent domain, of two-thirds of the 42nd Street project area, and the ultimate rejuvenation of Times Square was assured.

As I write in the spring of 2005, the project is still not complete. *The New York Times* head-quarters building on Eighth Avenue, which replaced the Merchandise Mart originally envisioned for the site, is under construction. But the plan that Koch initially approved and then nurtured is very close to what has been realized.

To walk along 42nd Street now is to marvel at how much it has changed. Instead of being one of the most dangerous, depressing streets in New York, it has more than reclaimed its position as one of the most exciting thoroughfares in the city and the world. At its eastern end, four new commercial buildings housing companies like Reuters, Ernst & Young, Condé Nast, and Skadden Arps have been built.

In the mid-block, several historic theaters, under the jurisdiction of the New 42nd Street, Inc., a non-profit organization set up during the Koch years, have been restored and now provide world-class entertainment to New Yorkers and visitors. These include the New Victory Theater, the city's premiere venue for live children's theater; the spectacular New Amsterdam Theater, renovated and operated by the Disney Organization; and the American Airlines Theater, operated by the Roundabout Theater Company. Two new hotels have been built on the block, as well as two movie complexes. Finally, as noted, *The New York Times* is constructing its headquarters building on Eighth Avenue between 40th and 41st streets, the last major element of the project.

Without the rejuvenation of Times Square, there would be no talk today about developing the far-west side of Manhattan. Without the rejuvenation of Times Square, today's positive image of New York would not be possible. And without Ed Koch, it is doubtful New York would have the rejuvenation of Times Square—one of the great urban success stories of the past century.

Carl Weisbrod was involved in the redevelopment of Times Square from 1978 until 1994, as Director of the Mayor's Office of Midtown Enforcement, Executive Director of the City Planning Commission, President of UDC's 42nd Street Development Project, Inc., and, under Mayor Dinkins, as President of the City Economic Development Corporation. He served for ten years as head of the Alliance for Downtown New York and now oversees the real estate operations of Trinity Church.

HAPPY BIRTHDAY
The Crossroads of the World is bustling in 2004. The building in the background, 1 Times Square, was the home of *The New York Times* 100 years ago, and gave its name to the area that had been known as Longacre Square.
Mike Albans

GOOD INVESTMENT
The control room of the Brooklyn Gas Company in the heavily subsidized Metrotech Center in downtown Brooklyn.
Andrew Savulich

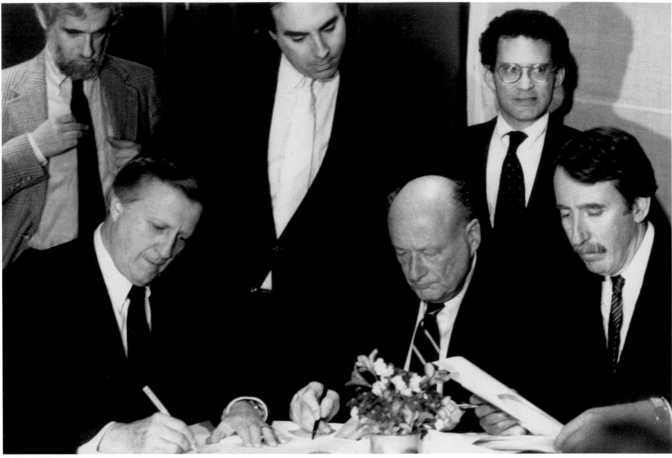

HARDBALL
Koch is decidedly not a sports fan, but having seen the Jets quit the city for New Jersey, he couldn't let the Yankees go, too. He signs a 1987 agreement with owner George Steinbrenner to keep the Yankees in the Bronx. State official Vincent Tese is at right.
Monica Almeida

RIDING THE WAVE OF ECONOMIC DEVELOPMENT
BY JOSEPH B. ROSE

Ed Koch took office in a city reeling from a series of economic debacles. Massive job losses, fiscal collapse, crushing tax burdens, population decline, and deteriorating services threatened the city's future. An exodus of corporate headquarters, long the symbols of the city's economic primacy, confirmed that New York had finally lost its immunity from the consequences of undisciplined taxing and spending. New York was poised to join other older American cities as an economic relic.

Only a few years later, the city had regained hundreds of thousands of jobs, was in the midst of a historic construction boom, achieved budget surpluses from surging taxes, and once again dominated the national and international capitalist systems. As champion of the free market, ally of the entrepreneurial developers, and scourge of the "crazies" who tried to thwart his plans, the feisty mayor basked in the glow of these striking successes. The liberal legislator from Greenwich Village who had no

private sector experience or even obvious interest in it seemed to have evolved into a visionary champion of urban economic leadership.

In fact, New York's dramatic economic recovery was mostly a function of the city's innate competitive advantages, innovative private sector and economic forces far beyond the city's control. To the extent that Koch administration policies contributed to the success, it was by refraining from destructively interfering in the manner of past administrations, which would have sabotaged the regeneration. The restraint was made possible by the mayor's fundamental indifference to having an economic development agenda, his disdain for long-term goals, and his personal and political animus for his political opponents, who generally advocated for more interventionist approaches.

To be sure, the Koch mayoralty achieved some economic accomplishments which deserve celebration, notably the preservation of a unique character for Broadway and the Theater District, a government-directed westward expansion of Manhattan's central business district, and the establishment of the costly but critical beachhead of the Metrotech commercial development in downtown Brooklyn.

Nonetheless, the majority of his active initiatives proved unsuccessful or largely irrelevant (many of the vitriolic criticisms of those initiatives were also excessive or unwarranted). Important new buildings, inspiring vision, and crucial structural reforms would be left for others to champion. The important and lasting economic development achievements of the Koch years were primarily defined by what the ornery mayor did not do.

An Economy in Transition

The years from 1969 to 1987 witnessed a dramatic transformation of the city's economy. Thousands of manufacturing businesses closed, jobs disappeared, and whole industries departed. Those that remained faced heavy tax burdens, deteriorating facilities, and inferior municipal services.

Blue collar jobs weren't the only ones to leave. Major companies also began to question the need to bear the high costs of keeping their corporate headquarters in New York City. They increasingly migrated to locations with new infrastructure that assured easier access, less expensive and higher quality housing options, lower taxes, and cheaper labor. Armies of back-office workers, clerks, and support staff followed the executives to the Sun Belt. More than 60 percent of New York's Fortune 500 headquarters skipped town. New York lost 600,000 jobs between 1969 and 1977.

The political establishment did not react well to the shifting climate. Accustomed to setting "the house rake" as high as necessary to support the powerful municipal unions, expansive liberal agenda, and influential outer-borough political machines, city leaders offered futile responses: raising taxes, creating bizarre regulations aimed at saving manufacturing by preventing competition from other land uses, appealing to Washington, and irresponsibly using debt from the capital budget to fund operating deficits. When the banks finally stopped lending new money while demanding payment of previous loans, a conspiracy theory was even concocted that charged the banks with luring the city into living beyond its means.

The hapless Abe Beame was discredited by the economic crisis, as were his organizational allies. The only question was which of Beame's liberal opponents would seize the mayoralty. Koch pulled it off by fashioning a campaign that appealed to the many voters disgusted with business as usual.

The election of a mayor free from close political ties and obligations to the usual suspects was a great blessing for the economy. Although Koch had paid lip service to the newspapers' calls for an improved business climate, lower taxes, and more jobs, it was a subject that he was neither interested in nor informed about. Even those Koch brought in to take charge of economic development have admitted that this was a subject they had known nothing about, to which they had given no thought, and for which they had no plan. Ironically, such detachment was a great asset. Instead of announcing a half-baked grand strategy to save the

city's manufacturing industries or establishing a jobs and industrial policy directed from City Hall, the Koch administration settled on becoming economic boosters, with the mayor as the chief cheerleader.

As Peter Solomon, Koch's deputy mayor for economic policy, explains in his comments to Columbia University's Oral History Archive of the Koch mayoralty: "The greatest single contribution of our administration to economic development was no specific project or policy, it was atmosphere and attitude....What we wanted to do was show that part of society that was not relying on government that the mayor cared, that we were not going to be capricious, we were not going to be belligerent. We were going to be supportive of them making a living and being in the city. Now that was a hell of a difference. That was a sea change for New York."

Whether Koch actually cared is debatable. His aides have said he gave the appearance of listening and, after instructing his appointees to do the right thing, would take a hands-off approach. As one of his senior economic officials said for the archives, "I never told the mayor anything and he never asked."

Yet Ed Koch did excel at the public performance. One of his appointees summarized the essence of Koch's leadership to be "Keep up the spirits, let them know that someone was in control....You know, an awful lot of government is symbolic leadership—to show people that you care, that you're involved."

Despite the mayor's concerns that "the private sector was ripping him off," his aides were also able to convince him not to raise taxes on business to even higher levels. Early in Koch's first term, Solomon prepared a comparative review of taxes on business to show the mayor how much greater the New York burden was than other jurisdictions. Solomon often had to refer to the study to get the mayor to restrain his tax-increase instincts. Successive deputy mayors with responsibility for the city's economy shared Solomon's outlook, and managed to protect the private sector from having to bear further burdens. Koch deserves credit for having consistently chosen wise economic advisors and for having followed their advice.

The strategy of cheering on the private sector while protecting it from further municipal predations proved successful. For while the manufacturing and commercial headquarters sectors had been in dramatic free fall since the late 1960s, other parts of the city's economy began to embark on a period of equally spectacular growth. While all large older American cities were confronting declining manufacturing economies and most also endured catastrophic population loss, New York was transforming itself. Washington's regulatory reform of the financial markets, explosive growth in international trade, and the emergence of personal and financial services as the dominant employment sectors turned New York from economic invalid to powerhouse.

By the mid-1980s, New York found itself leading the nation in new business starts and attracting major offices of international banks and law firms. Its traditional competitive advantages of density, innovation, and creativity yielded a net 400,000 new jobs from 1976 to 1986, swelling the tax roles and virtually wiping out the economic trauma of the previous period. And the new jobs created by the service economy generally paid more and gave greater benefits than those of the industrial economy.

As the mayor enjoyed the good fortune of holding office during an economic recovery, his political opponents railed at his refusal to revert to the familiar indifference of previous administrations. Koch came under intense criticism from many in his own party for granting tax abatements to businesses in exchange for long-term commitments to stay in the city. He was excoriated for his administration's unwillingness to support the imposition of commercial rent control to prevent the displacement of businesses as the economy heated up. That the administration was, in fact, quite stingy with its tax abatements and refused to offer the kinds of benefits granted by other jurisdictions made little difference in liberal political circles.

Moreover, the total value of tax concessions granted businesses was minimal in the context of the enormous budgets of government and the tax

GOING UP
The mayor, Andrew Stein, and builder Jack Resnick beside a model of Seaport Plaza at South Street Seaport in 1982. It was not the kind of event Koch enjoyed, as his face suggests.
Willie Anderson

burdens that remained. Nonetheless, the critics howled. To the political class, any concession on taxes was a "giveaway" to corporate interests who should gladly pay heavily for the privilege of doing business in the five boroughs.

As deputy mayors Alair Townsend and Kenneth Lipper fought to institutionalize the tax abatement programs, making them appear "as of right" to remove them from the political arena and avoid the discretion that could easily lead to corruption, Koch fumed. Never one to easily surrender discretionary authority, the mayor reluctantly allowed his economic advisors to prevail. That acquiescing to their arguments meant denying victories to his political antagonists did not hurt.

Active Measures

Of course, economic cheerleading did not constitute the whole of the administration's policies. Several attempts to actively guide the course of development did have a lasting impact. The first was Bobby Wagner's determination to shift the focus of commercial development from the East Side of Manhattan to the West. As the economy gathered steam and construction cranes finally began to reappear, it seemed as if every possible development site in east Midtown would have an office tower. As chairman of the Planning Commission, Wagner initiated a plan to offer incentives for development on the West Side and constrain new development on the East Side. The

Midtown zoning adopted in 1982 did not halt activity to the east, but it definitely sparked activity to the west, where tens of millions of square feet of new commercial construction established a new business core. The first-class office district that now stretches from 42nd Street to 59th Street, west of Sixth Avenue, is very much a result of the Koch administration's deliberate efforts.

Wagner's successor as planning commission chair, Herb Sturz, realized that the important Broadway Theater District stood right in the path of this new surge of development and under his

CANDOR
Peter Solomon in May, 1978, when Koch names him deputy mayor for economic development. Solomon told the oral history project at Columbia University that Koch's biggest contribution was changing the government's anti-business attitude. "We are going to be supportive of them making a living and being in the city" is how he describes the new approach.
Frank Russo

leadership, City Hall responded with valuable foresight. To honor commitments made by previous officials, Sturz had reluctantly supported development of the unfortunate Marriott Marquis, which replaced two legendary Broadway dramatic houses with a massive structure that turned its back on the Great White Way, and created an awkward new theater several levels off the street at one of the district's most prominent locations. As if to atone for that project, Sturz resolved to protect the character of the Theater District and worked with the Landmarks Preservation Commission to assure the protection of many of the remaining theaters. Sturz also worked to assure that the area would maintain its trademark dazzling lights and signage.

Despite howls from the developers and the investment bankers who planned to occupy new buildings in the area, Sturz held fast and joined with a coalition of community and civic groups to maintain a balance between new development and one of the city's most vital tourist attractions and cultural assets. While the mayor himself was barely involved with the issue, he once again deserves credit for having recruited capable aides and supporting them.

The one large project to receive administrative backing that was clearly a catalyst for future success was Brooklyn's Metrotech complex of office buildings. First-class commercial development in downtown Brooklyn was a cherished goal of Brooklyn's borough president Howard Golden and a handful of civic groups, corporations, and institutions in the borough. Urged on by Golden and led by city official turned developer Bruce Ratner, Koch allowed Deputy Mayor Townsend to assemble a generous package of city and state tax and other subsidies to convince Chase Manhattan Bank to join Brooklyn Union Gas in committing much of its back-office space to the Brooklyn project instead of moving to New Jersey.

A telling indicator of how unique the efforts were to woo the tenants was the appeal to the Police Department to clean up the area and establish a visible presence on the day the Chase Board of Directors was touring the location. The effort paid off and Metrotech has served as an anchor for subsequent efforts to attract investment to downtown Brooklyn. Unfortunately, that other businesses might also appreciate clean streets and a police presence was an economic development concept left to be grasped by future mayors.

In those instances where there was not a borough president to champion a project and manage the politics, the Koch administration fared far worse, especially in Manhattan. Many of the most noteworthy economic development fiascos of the last half-century were grand projects with which Koch was most personally identified. Westway, the redevelopment of Columbus Circle and the attempt to develop the West Side's rail

yards were spectacular failures that became symbols of the inability to get ambitious projects done in New York City.

Whatever its merits or flaws, Westway collapsed because city officials did not ensure that proper environmental studies were prepared. The redevelopment of Columbus Circle fell victim to Koch's inability to view the city's most prominent publicly controlled site as anything other than an opportunity for a big payday to the city treasury, and the West Side rail yards effort collapsed from the imposition of too many governmental burdens. Of course, all these projects presented problems that would have challenged any leader, but the fact that each was successfully developed by later mayors is testimony to the limits of the Koch style.

In the wake of the Koch era, after a huge economic boom that still left most of New York's waterfront abandoned and unused, and with many of the most publicized development proposals existing only as symbols of futility, many New Yorkers came to share one of Koch's deputy mayor's conclusions—that "You can't get the big things done." This is a dispiriting notion in the city of Roebling, LaGuardia, and Robert Moses. Fortunately, future mayors did not succumb to such sentiments and today we have a thriving West Side waterfront, a vital and colorful 42nd Street, a dynamic Columbus Circle, and thousands of new housing units and a new park on the Upper West Side.

Conclusion

Ed Koch was a good mayor. At a time when the city was on its knees, he refused to succumb to defeatism or a sense that New York's best days were behind it. He recruited dedicated and talented people and he supported them in the face of adversity. They managed the city's finances according to strict standards and raised confidence in the competence of city officials. The crucial mass transit system began to be restored, the city's park system began to be reclaimed, and a massive commitment to affordable housing was made. There is much to celebrate about the accomplishments of the Koch administration.

SAVED
After an initial misstep, the city protected the character of the Broadway Theater District, and used the Landmark Preservation Commission to preserve individual theaters.
Matthew Roberts

But it is important to understand that the economic recovery occurred primarily because of the dynamics of New York's private sector operating in a competitive global marketplace. The Koch team did have the insight not to undermine the market forces that were rescuing the city. While this role was more passive than Koch might have one believe, it was still necessary and historically significant. Under him, government backed off and gave the economy room to heal itself. This was a critical transition from previous approaches, and was neither inevitable nor generally appreciated. Koch endured virulent and sustained criticism from many quarters for his administration's restraint. New York is lucky that the mayor had the political temperament to stand firm.

Koch was famous for asking everyone he met, "How'm I doing?" On the economy, the answer is "pretty well." That Koch himself might not appreciate why he succeeded remains one of the ironies of his mayoralty.

Joseph B. Rose was Special Assistant to Senator Daniel Patrick Moynihan and Chairman of Manhattan's Community Board Number 5 (Midtown) during the Koch administration. Under Mayor Giuliani, he was Chairman of the New York City Planning Commission, from 1994 to 2001. He is currently a partner of the Georgetown Company, a real estate development firm active throughout the United States.

BODY LANGUAGE
In June, 1989, the corruption scandal is taking a toll on Mayor Koch and helping to launch Rudolph Giuliani's political career. Before the year is out, however, David Dinkins defeats both to become the city's first black mayor.
Harry Hamburg

SCANDAL TIME
BY SAM ROBERTS

In New York, parking is a test of primal political clout. Thanks to the growing influence of new immigrants, you don't have to move your car from alternate-side spots on six Muslim holy days and Chinese New Year any more, in addition to all those Christian, Jewish, and national holidays. About two cents of every dollar the city raises comes from parking tickets, which is one reason that changing the regulations—to accommodate diplomats or meter-feeding churchgoers who have to "pay to pray" on Sundays—is so touchy. No surprise, then, that in the mid-1980s a volatile mix of parking and politics also produced New York City's biggest corruption scandal in decades.

"It was," Mayor Koch said to me in an interview in the spring of 2005, "the most painful period in my whole life. I thought of committing suicide. I thought to myself, I'm one of the most honest people the city has ever had as mayor. Am I going to be remembered as a crook?"

The scandals, as they were called collectively, were really several largely unrelated corruption cases, all linked by greed and arrogance among people in positions of public trust, but some of them not even involving municipal officials. They triggered a feeding frenzy of investigations by the authorities and by journalists that would cost two borough presidents their jobs and one his life; send

TRIALS AND TRIBULATIONS
Opposite page: Stanley M. Friedman, center, Bronx Democratic leader, at his 1987 federal trial with wife Jackie and lawyer Thomas Puccio. Friedman testified that he once received $10,000 for making a single phone call to help a client.
Misha Erwitt
Above, left: Bess Myerson, star of the "Bess Mess," leaves Manhattan Federal Court.
Misha Erwitt
Above, right: The mounting strain shows on Koch as he discusses the resignation of ally and friend Donald Manes.
Ed Molinari

to prison one of the city's most powerful Democratic politicians; subject a former Miss America to a criminal trial at which one witness was the fidgety mayor of New York; all but paralyze a paranoid city government tangled in sometimes competing probes; and mar Koch's third term and contribute to his defeat for a fourth, even though he was never personally implicated.

As 1986 began, Koch was being sworn in for a third term. The ceremony, on the eve of a public inauguration, was private. The mayor had a cold. And he was worried. He had been reelected again by a landslide, but, after having salvaged the city's fiscal credibility he was facing hundreds of millions

of dollars in federal budget cuts. Yet the year would be dominated, and City Hall often diverted, by the aftershocks of a scandal that was just beginning to rattle politicians in Chicago. Federal agents there overheard the head of a collection agency describing how payoffs were also being made in New York.

Only eight days later, on the night of January 9, Donald R. Manes, the 52-year-old Queens borough president, slashed his ankle and wrist in what appeared to be a suicide attempt. Koch visited him in the hospital and kissed his forehead. After he was released and implicated in the scandal, Koch called him a crook. In February, Manes resigned. On March 10, Geoffrey G. Lindenauer admitted in

STORM COMING
Donald Manes, left, and Mayor Koch sign cement at the New York Hall of Science renovation in 1982. Manes committed suicide in 1986 when his role in the corruption scandal was revealed.
Nick Sorrentino

federal court that, as deputy director of the city's Parking Violations Bureau, he had been extorting bribes on behalf of himself and others for years. Three days later, Manes killed himself by plunging a knife into his heart in the kitchen of his home. By the end of March, Lindenauer and another transportation official had been indicted on federal racketeering charges. Robert M. Morgenthau, the Manhattan district attorney, brought fraud charges against Bronx Democratic leader Stanley M. Friedman, a former deputy under Mayor Abraham Beame, and a guest at Koch's private inauguration.

Friedman was accused of bribing Manes and Lindenauer to win a $22 million contract for Citisource, a company he represented that was supposed to issue parking tickets on a handheld computer. Friedman would be convicted in a sensational federal trial and sentenced to 12 years for racketeering, conspiracy, and mail fraud. The trial

testimony, the journalists Jack Newfield and Wayne Barrett wrote, "constituted an indictment of the Koch administration—the patronage decisions, the dismissal of whistleblower warnings, the unsupervised autonomy of Manes' P.V.B. operation, the Citisource award and its protection even after the company repeatedly defaulted."

The trial and subsequent revelations, while not necessarily related, nonetheless exposed a pattern of corruption, influence peddling, and patronage that clashed mightily with the slogan Koch campaigned on in 1977 when he was running as the competent, apolitical professional against the ballyhooed charisma of John Lindsay and the clubhouse partisanship personified by Abe Beame. Koch had first won party office by defeating Carmine De Sapio, the boss of Democratic bosses, in a Greenwich Village district leadership race. But running for mayor in 1977 (and then again for

governor in 1982), he discovered that he needed the support of party leaders to get elected and to govern as much as they depended on access to and favors from City Hall. Koch operatives struck secret deals with, among others, Friedman and the Brooklyn Democratic leader, Meade Esposito—deals that would blow up in their faces. They were abuses of power that collectively inspired the title of Newfield and Barrett's book, *City for Sale* (Harper Collins, 1988).

The charges and trials stunned the city, the Democratic political establishment, and even many of the city's journalists, who typically had depicted Manes and Friedman as colorful characters—or at worst, amiable rogues ("Crime does not pay… as well as politics," said a sign in Friedman's office). The revelations also tested assumptions and loyalties forged in earlier campaigns and in the camaraderie of City Hall.

Koch acknowledged at the time that he had allowed Democratic leaders to exert "undue influence" over city government but insisted, and nobody proved otherwise, that he was as surprised as anyone at the price they exacted. "I am embarrassed, I am chagrined, I am absolutely mortified that this kind of corruption could have existed and that I did not know of it," he said at the time.

"Donald Manes was considered my successor," Koch said in the 2005 interview. "Everybody loved him. Nobody had a hint of scandal about him. Friedman had been given a sinecure as a member of the water board. I fired him. (He sent me a card saying, 'have you noticed since you got rid of me you've had droughts?') But he was very supportive in getting councilmen to support our program. I thought he'd go up to the line, but never past the line, in using his office."

Chris McNickle wrote, in *To Be Mayor of New York* (Columbia University Press, 1993), that "Koch felt betrayed by his cronies, but the city felt betrayed by the mayor." Friedman, who served four years in prison, said recently: "In hindsight, Koch should have felt betrayed. Unfortunately a lot of people, family and friends, were let down by my conduct, and no one has more regrets than Stanley Friedman."

But if the mayor felt betrayed, was it, in part, because he had been naïve? "I believe there's nothing wrong in terms of fungible jobs, no skills, ditchdiggers, to say to county leaders, district leaders, Donald Manes, Stanley Friedman, 'Sure! Why not? What's the difference?'" he said at the time. But some of those leaders got greedy and, again, the practice contradicted the preaching. His Talent Bank, ostensibly a vehicle to recruit more blacks and Hispanics to city government, was hijacked and transformed into a patronage mill. "In practice," John H. Mollenkopf wrote in *A Phoenix in the Ashes* (Princeton University Press, 1994), the Talent Bank "became a computerized patronage-hiring system grafted onto an affirmative action program."

BESS WALKS
Myerson is all smiles after her acquittal on charges of trying to bribe a judge in her lover's divorce. The seedy details, however, ruin her public image and lead to estrangement from Koch.
Dan Cronin

Other inquiries concluded that Koch's department of investigation was complicit in a "systems failure" for fumbling inquiries into the Parking Bureau for four years. Edward Sadowsky, a respected former city councilman, concluded that the mayor had "shown questionable judgment, not on policy issues but on a personal basis." ("Sometimes I wish I were the only person in government, Hydra-headed, instead of having to depend on the frailty of other people," Koch said in 1989, after it had been revealed that officials in charge of his so-called Talent Bank frantically destroyed documents when they learned

that a state commission was investigating patronage. "But you're in charge of 334,000 people and you're at their mercy.")

Jay L. Turoff, the taxi commissioner, pleaded guilty to a scheme to misappropriate taxi medallions and more than $500,000 in taxi revenues. Bess Myerson, the former consumer affairs commissioner, one-time Miss America, and a prominent supporter during Koch's first race, was acquitted of all charges, but, one editorial still concluded, "There was evidence, even if insufficient to persuade the jurors, that the commissioner bribed the judge with a city job for the judge's daughter to win favorable rulings" in Myerson's boyfriend's divorce case.

"I went into a state of clinical depression," Koch told me as he looked back. "I couldn't get out of bed. I cried without reason." He even ordered police to remove a gun that had been secreted in a "panic room" built in an upstairs bathroom at Gracie Mansion. "Two incidents cheered me up," he recalled. "Cardinal O'Connor called—he was the only one who ever said to me, 'Ed, I know you're depressed. But everybody knows you're honest.' He said nobody thinks you're a crook. Then the following weekend I'm still reading *New York Times* editorials denouncing me for not being observant enough. The U.S. attorney, the d.a. didn't know. The department of investigation didn't know. How the fuck do you think I should know? It was like knives in my stomach, my heart. And that Saturday I flew by helicopter to participate in the archdiocese's Special Olympics in the Bronx. Meeting me is the police chaplain. He said, 'Mayor, can I be frank with you?' Yes, I said. 'Can I really be candid with you?' He says, 'Fuck 'em!' You can't appreciate what that meant. My face lit up."

In deciding to run for a fourth term in 1989, Koch was also seeking vindication, in part because of the wounds inflicted by the scandals. When the scandal broke, I remember him declaring, "I will never run away to fight another day. I want to fight today." In the 1989 Democratic primary, he fought, and lost, to David N. Dinkins, in part because of the scandals.

In the nearly two decades since the scandals erupted, no systemic corruption has been uncovered on the scale of what happened in the 1980s, in part because of safeguards that were imposed then. Arguably, by further discrediting the trifurcated government structure that had existed for nearly a century, the scandals also created a climate in which it was politically more feasible to abolish the Board of Estimate and shift much of the borough presidents' power to the mayor and the City Council. This occurred after the United States Supreme Court declared that the existing structure violated the principle of one person, one vote. The scandals also ultimately helped catapult the federal prosecutor, Rudolph W. Giuliani, who personally handled the Friedman trial, into the mayoralty.

In 1989, before the Democratic primary, Giuliani had repeatedly attacked Koch for responding to corruption allegations with "his eyes closed, his ears clogged and his mouth open." Once Koch lost the nomination, though, and Giuliani was courting supporters, his tune changed. "The reality is this," he said. "I investigated corruption in the Koch administration. I prosecuted several commissioners in the Koch administration and way back then made the point that there was no investigation of Ed Koch because there wasn't a scintilla of evidence that suggested that."

Still, the corruption occurred on Koch's watch. And after 12 years, the voters were unforgiving.

Sam Roberts is urban affairs correspondent of *The New York Times* and the author of *The Brother: The Untold Story of Atomic Spy David Greenglass and How He Sent His Sister, Ethel Rosenberg, to the Electric Chair* (Random House, 2001) co-author of a biography of Nelson Rockefeller, published by Basic Books in 1977, and the author of *Who We Are: A Portrait of America* (Times Books, 1994) and *Who We Are Now: The Changing Face of America in the 21st Century* (Times Books, 2004).

A HOUSING LEGACY
BY MICHAEL GECAN
AND REVEREND JOHNNY RAY YOUNGBLOOD

In the early 1980s, no one knew that Ed Koch would end up making an unprecedented and still-unmatched commitment to the reconstruction of New York City—not even the mayor himself.

We vividly remember a testy exchange with Stan Brezenoff, the most powerful deputy mayor at the time, over this very issue. We had come to City Hall with a small team of leaders from east Brooklyn. The community we represented was in terrible shape. Arson fires raged in broad daylight as landlords abandoned their worthless buildings. Families poured out of the neighborhood. And little or nothing was being built—not in Brownsville or Bushwick, not in Harlem or East Harlem, not in Mott Haven or East Tremont, or scores of other dying communities.

The city had survived its fiscal crisis but was locked in a life-or-death physical crisis—its housing stock collapsing, its social fabric fraying. There were thousands of abandoned buildings, more than 100,000 vacant units, and hundreds of acres of rubble-filled land. Population had plummeted by 800,000 or so, from a previous high of 8 million. Along the Cross Bronx and Brooklyn-Queens Expressways, drivers hurried through desolate canyons—gutted building after gutted building. Plywood, or nothing at all, replaced windowpanes. Small fires started by drug dealers or the down-and-out flickered inside hallways and basements. Gun battles raged in courtyards or across the Interboro Parkway at night. One day, a group of visiting mayors toured the devastation. When asked by a reporter for their impressions, the mayor of Boston said, "I have seen the beginning of the end of civilization."

One city commissioner, overwhelmed by the challenge, plastered the plywood with decals of flower-pots and families in silhouette. This prompted *The Village Voice* to write that someone should put the decal of a brain on the forehead of the city official.

In the great foundations and planning schools and editorial offices, the elites of New York were puffing on their pipes and impressing one another with terms like "benign neglect" and "planned shrinkage." What they meant was: let these neighborhoods die, reduce services in these hopeless corners of New York, don't throw any more good money after bad.

Defeat and despair were in the air. We all sensed it. And, on this day in City Hall, we weren't buying it. We challenged Brezenoff, who had as good a feel for poor communities as anyone who ever sat in his chair, saying that the administration had no housing policy.

Brezenoff bristled, "Yes, we do."

"What is it?"

"Federal money."

The problem was that there wasn't nearly enough federal money to meet the needs of our profoundly damaged city. Ronald Reagan, the newly elected president, had other priorities. He was so disconnected from the needs of urban America that he didn't even recognize his own secretary of housing and urban development, Sam Pierce. At a White House gathering, in a famous and telling encounter, the president asked Pierce which city he was mayor of.

GOING, GONE
Once-sturdy housing in the South Bronx was reduced to rubble, like this building near Simpson Street in 1979.
Tom Cunningham

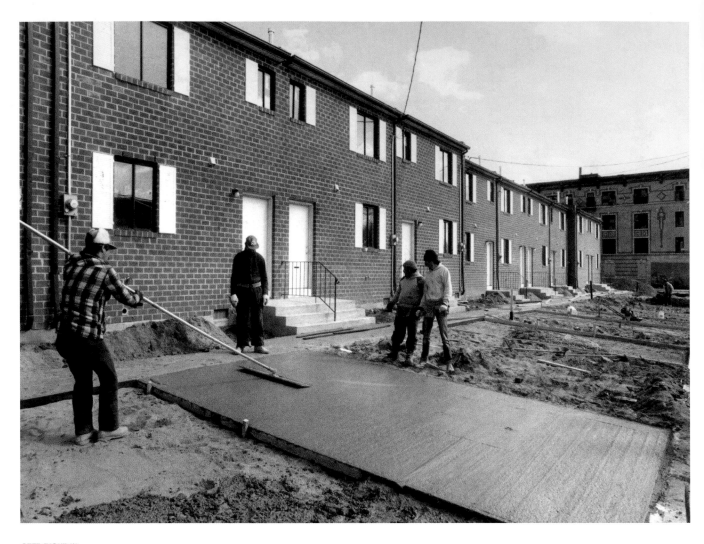

STEP RIGHT IN
A construction crew prepares the sidewalk of new Brooklyn houses built in 1985 under the Nehemiah plan.
Dan Cronin

Five years later, in 1986, the rebuilding of New York was well underway. The East Brooklyn Congregations group was finishing the first 1,100 Nehemiah homes in Brownsville and was preparing to build another 1,800 in East New York. The New York City Partnership, under Kathy Wylde's leadership, had constructed thousands of homes. The Community Preservation Corporation had completed the renovation of thousands of apartments in Washington Heights, and executive director Mike Lappin was expanding into other neighborhoods. In the Bronx, Father Louis Gigante was injecting new life into a God-forsaken corner of the borough. To the west, leaders like Father Bert Bennett and Father John Grange and Lee Stuart were positioning

South Bronx Churches to build 1,000 new homes. Further north, Mary Daily and a team of clergy and community leaders were fighting a trench battle, taking back building after building and returning them to useful life. In Harlem, the Reverend Calvin Butts was hard at work.

All of this began on Ed Koch's watch and was then accelerated by his unprecedented commitment of billions of city dollars into the rehabilitation of existing units and the construction of new affordable homes.

In the 20 years since Koch announced his ten-year plan, more than 200,000 units of housing have either been rehabilitated or built in New York. Today, there are approximately 3,000 vacant city-owned

units left. Almost every large site that was vacant is filled with new homes, new families, and new hope. Recently, we conducted a tour of Brooklyn for some foundation executives from Maryland. After three hours of driving, one of the executives asked, "Where are the devastated neighborhoods?" We answered, "You missed them."

One way to understand the importance of Koch's housing plan is to look at the cities that didn't follow New York's lead. Baltimore still has nearly 20,000 abandoned structures, and its population has dipped from a high of 1 million to 600,000. Philadelphia has nearly 30,000 abandoned buildings, and a robust city of 2.1 million now has 1.4 million residents. And the city of Chicago has 108,000 abandoned housing units and shows sharp population declines in almost every one of its African American neighborhoods.

So what happened between that frosty exchange in City Hall in the early 1980s and the announcement of the mayor's vast housing plan just five years later? We've identified four major factors that contributed to New York's remarkable turnaround.

First, when we walked out of City Hall that day, we didn't throw our hands up and say, "Woe is us." In true New York fashion, we didn't take no for an answer, we didn't wait for city government while the city was waiting for the federal government. We rolled up our sleeves, recruited former *Daily News* columnist and home-builder I.D. Robbins, and went to work.

A major step was finding an ally who bridged the gap between our organization and the mayor—the late bishop Francis J. Mugavero, then the leader of Brooklyn and Queens. Koch had made it very clear he didn't want to deal with our organization. For years, he seemed unable or unwilling to say the words "East Brooklyn Congregations" or the initials "EBC." And we tended to have a low opinion of those who withheld the most basic form of recognition—our name. The one thing that we and the mayor did agree on was that Bishop Mugavero was one of the finest religious leaders of his time. The mayor would eventually demonstrate his

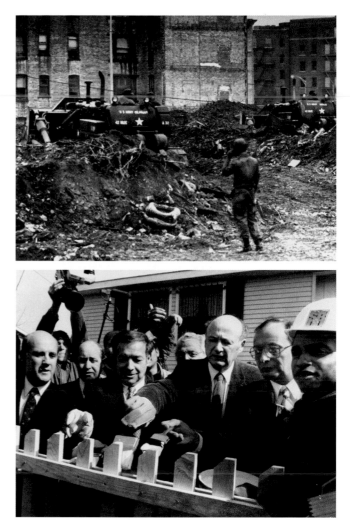

Top: WAR ZONE
A U.S. Army unit clears rubble in the 1980 Bronx cleanup. Decay, arson, and abandonment was so bad that it looked as though a bomb hit the area.
Tom Monaster

Bottom: PHOTO-OP
There is a big turnout for the final strokes of a Bronx project in 1983, but two more years pass before Koch shifts affordable housing production into high gear. Front row, from left: City Controller Harrison J. Goldin, Bronx borough president Stanley Simon, Koch, and Senator Alfonse D'Amato.
Clarence Davis

appreciation of the bishop by awarding him the city's coveted LaGuardia Medal. We would later show the same regard for the bishop by dedicating a section of Mount Pisgah Baptist Church (once the bishop's home parish, located in Bed-Stuy, when it was called Saint Anselms) to the memory of this great man. We know of no other Roman Catholic bishop honored so highly by a Jewish mayor, a Baptist congregation, and a Saul Alinsky organization.

We raised our own construction financing from religious sources. People who had never

Top: POINT MAN
Deputy mayor Stanley Brezenoff.
Anthony Casale

Bottom: GENERATIONS
Robert Wagner Jr., left, with his father, the former mayor, in 1977. Bobby, as he was called, is credited with helping the city fill the housing gap left by Washington.
Gene Kappock

raised more than $100,000 for their local organization, people who often struggled to make ends meet in their daily lives, went out and raised $8 million for a revolving construction fund for the first Nehemiah effort.

We also organized the east Brooklyn community into an irresistible and disciplined force for social change. We knew that Ed Koch could be resistant, cutting, dismissive, and difficult, but was capable of cooperating with organizations and individuals he disliked. So, even though there was confrontation, conflict, testiness, "the people had a mind to work," as the Old Testament book of Nehemiah reported. The work, on a massive scale, went forward. The homes were built. And the mayor proved that he valued the larger public good—the rebuilding of the city—more than his personal feelings about some of those involved in the effort.

Second, the mayor had a knack for finding and appointing incredibly capable and committed housing officials. We think that two of them, Felice Michetti and Kathleen Dunn, typify this group. Michetti started on the ground, working in the Bronx, before becoming deputy commissioner under Koch, housing commissioner under Mayor David Dinkins, and then, more recently, president of Grenadier Realty. Dunn also worked her way up from neighborhood housing efforts to become Michetti's deputy commissioner, and then to play a major role at the Community Preservation Corporation.

Michetti's office wasn't filled with charts or graphs or pictures of the Rockies. It was decorated with pictures of people—smiling New Yorkers who were proud to own a modest home in East New York or an apartment off the Grand Concourse. Focused on these New Yorkers, she and Dunn built good working relationships with not-for-profits like the Enterprise Foundation, the Local Initiatives Support Corporation, and Neighborhood Housing Services. The city's strong capital investment generated other funds—complex tax credit financing and other creative forms of subsidies. Koch had the good sense to let people like Michetti and Dunn, Mark Willis and Paul Crotty, and the late Bobby

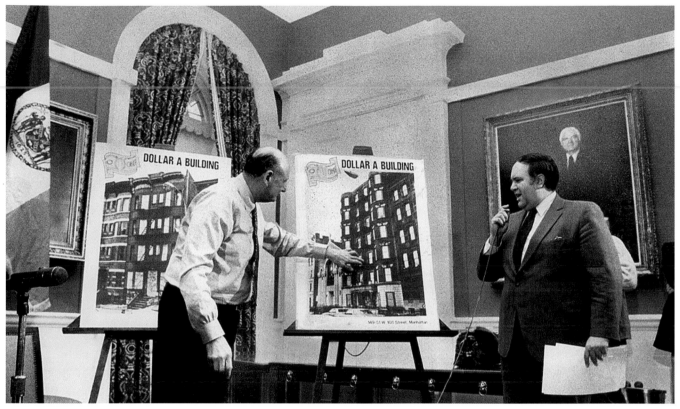

SUCH A BARGAIN
In the early years of the administration the city is saddled with so many run-down apartment buildings that it tries to sell them for $1 each. Koch helps Housing Commissioner Anthony Gliedman explain the program.
Clarence Davis

Wagner Jr. do their work. Other cities would kill for talent like this.

Third, Koch stopped waiting for the feds and took action in a way that no American mayor of his era did: he began the investment of $5 billion in housing. In 1989, the city spent nearly four times more on housing than the next 50 cities combined: $100 per resident on housing compared with an average of less than $6. Remember what the elites were saying at the time. Remember the prevailing "wisdom" about trying to rebuild African American and Hispanic neighborhoods. Remember the national catastrophe taking place in hundreds of American cities—abandonment, devastation, flight to the suburbs. Koch put his money where his mouth was and showed that a great, wounded city could be revived.

Fourth, he institutionalized this effort in way that made it possible, perhaps inevitable, for mayors Dinkins and Giuliani to maintain and continue. When Mayor Bloomberg announced his plan to construct

or renovate 65,000 units of housing early in his mayoralty, most New Yorkers didn't blink. We've come to expect the mayor of the city of New York to be a master builder.

That expectation is Ed Koch's greatest legacy—along with all the children sitting on all of the stoops that didn't exist in 1982 and 1983.

Reverend Johnny Ray Youngblood is the senior pastor of both Saint Paul Community Baptist Church in East New York and Mount Pisgah Baptist in Bedford-Stuyvesant. He is the co-chairman of East Brooklyn Congregations—the sponsor of the EBC Nehemiah Plan—and also co-chair of the network of citizens organizations called Metro New York Industrial Areas Foundation.

Michael Gecan is the founding organizer of EBC and senior IAF organizer in New York.

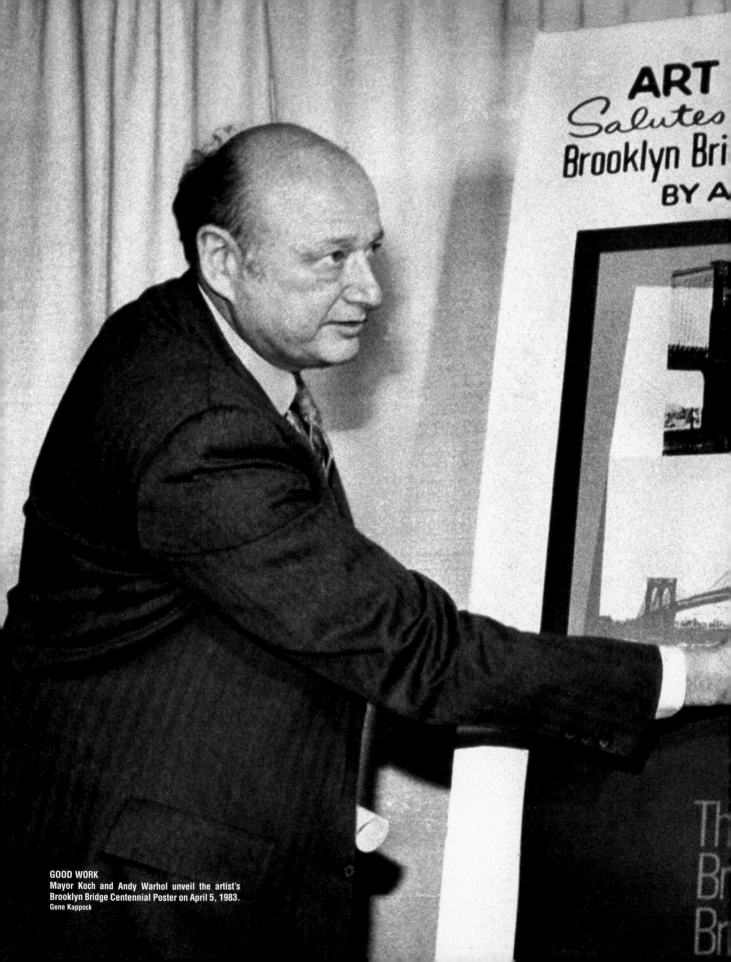

ART
Salutes
Brooklyn Bri
BY A

Th
Br
Br

GOOD WORK
Mayor Koch and Andy Warhol unveil the artist's
Brooklyn Bridge Centennial Poster on April 5, 1983.
Gene Kappock

CREATIVE SOLUTIONS
BY RONAY MENSCHEL

Culture and parks—fundamental to the city's character and habitability—were at a crossroads when Edward I. Koch took office in 1978. The Department of Cultural Affairs had been created just two years before with a broad mandate, but little funding. The Parks Department was responsible for over 1,500 parks, playgrounds, swimming pools, malls, and public spaces, as well as beaches, marinas, golf courses—a far-flung empire—in the face of a severely reduced budget. Parks across the city displayed the most visible wounds of the financial crisis. They were in deplorable condition.

The two new commissioners confronted very different challenges, but there were remarkable parallels in the initiatives they undertook. Most notable were the partnerships they forged with New York's philanthropic community. And they both had the courage to cede some authority and operating responsibilities to private partners. Their actions heralded a new era in government, privatization, a concept we now take for granted and use in many areas.

The leave Mayor Koch gave to Cultural Commissioner Henry Geldzahler and Parks and Recreation Commissioner Gordon Davis to set their own agendas was typical of the mayor's management style. He asked for monthly reports and often offered ideas, but he recognized that if the city was to be managed better, leadership and "ownership" at the agency level were required. It is also notable that both commissioners were individuals the mayor had not known before meeting them at the recommendation of the Transition Team's Selection Panel.

Leadership was further decentralized in the Parks Department to the borough level and to administrators of major parks. This fostered a lasting turnaround in employee morale and professionalism and management effectiveness. Three of the top Parks officials today, including the present commissioner, Adrian Benepe, have had long careers in the department, beginning as members of the inspired Urban Park Rangers.

By the time the financial condition improved several years into the administration, and expense and capital dollars increased, both departments were ready to leverage city investments to benefit their constituencies and induce private support. The public/private partnerships launched early in the administration have not only lasted, but evolved to provide substantial private funding and shared operating responsibility.

Doing More with Little

In 1978 the Department of Cultural Affairs had little discretionary money, but high expectations for the role of culture in the administration's agenda. Commissioner Geldzahler was determined to do more for the hundreds of small cultural organizations that served emerging artists, reflected New York's cultural diversity, and nurtured specialized artistic activity. He looked to non-traditional funding sources and devised programs that were inexpensive to administer.

With support from City Hall, federal community development funding was tapped for arts groups in low income neighborhoods, many of which were black and Latino organizations. State and federal youth funding was tapped, together with private contributions, for an arts exposure program that enabled local arts groups to conduct workshops and perform in schools. This later turned into a major arts-in-education initiative that drew on the skills and resources of arts agencies, including the major cultural institutions, to help make up for the failure and near-elimination of arts education in the public schools.

A creative use of the department's position in the arts community was the establishment in 1978

of the Materials for the Arts program. Low in overhead, it offered a way for companies to give away excess supplies and equipment to cultural organizations and artists. The program continues today with materials worth $3.8 million exchanged in 2004.

The department's expense budget increased every year in the Koch administration, from $24.8 million in the 1978 fiscal year to $87.07 million in the 1989 fiscal year; $69.6 million of this was allocated to the Cultural Institutions Group, then numbering 31 members. (Most of these selected institutions, which ranged from large museums and performance spaces to small arts centers, occupy city-owned property.) Starting in 1981, funds were added to the mayor's budget by the Board of Estimate, and later the City Council, during the adoption process. This practice continues today

BROOMS UP
Koch's first parks commissioner, Gordon Davis, gets credit for starting the restoration of the city's battered and neglected green spaces.
James McGrath

GOOD NEWS, BAD NEWS
Idyllic scene of rowing on Central Park Lake is shattered by the view of the burned-out shell of the Boat House, seen here in 1986. It has since been restored and is now a popular restaurant.
Above: Tom Monaster Opposite page: Robert Rosamilio

and has become an expected ritual with City Council members adding program and capital funds for the cultural agencies in their districts.

The most notable budget growth took place in funding for programs. Beginning with approximately $1.5 million in 1978, used largely for public concerts, this portion of the budget reached $13.9 million in 1989, funding 450 organizations in response to proposals submitted for exhibitions and cultural events. The city became the second-largest government funder of the arts in the country, exceeded only by the National Endowment for the Arts.

During the 1980s, the greatest impact the agency had on cultural life in the city was through its capital budget. The availability of significant sums for facility improvements and even expansion inspired a number of institutions to undertake major capital projects by combining public and private funds. The southwest wing at the Metropolitan Museum of Art was built with $8 million in city funds combined with $17 million in private dollars. At the Brooklyn Botanical Garden, the city contributed nearly half the cost of a $21 million project to reconstruct the Palm Court. Restorations were carried out at the American Museum of Natural

History, Snug Harbor Cultural Center, The New York Public Theatre, and the Museum of the City of New York. Strikingly, the Metropolitan Museum doubled its special exhibition space for temporary exhibitions in the Koch years. A total of $39.2 million in capital funding was provided by the city, which was matched by more than this amount for the creation or expansion of numerous galleries. Not surprisingly, the Met's attendance grew, achieving its high point in 1998 with 5.4 million visitors.

Early on, some people questioned putting money into the cultural and parks budgets when the city was struggling to balance its budget and had so many other needs. But the mayor always believed it was important to support those institutions. Asked about the controversy in 2005, Ed looked back and said, "How could it be otherwise? I was surrounded by people totally dedicated to our parks and the arts." He cited a number of people in the administration, including me, then added: "My first budget director, Jim Brigham, was in love with the New York Botanical Garden and I loved the Metropolitan Museum of Art. It is amazing that we were able to restrain our passions for the parks and the arts so that there was something left to fund the balance of the city's budget needs."

By 1989, the city's capital commitment had reached $75.9 million, with 142 capital projects in progress in all five boroughs. The execution of some of these projects was aided by "passing through" to the private institution the city's share of the project cost. This was a bold move and contrary to the practice of an agency administering any project that used city funds. The pass-through provision allows the institutions to effect closer monitoring and better financial terms for their projects.

Percent for Art

At the same time, art was becoming a part of capital projects of all city agencies through the Percent for Art program. In 1982, a law championed by Mayor Koch was passed requiring that 1 percent of the budget for municipal capital projects be spent on the purchase, commission, or conservation of works of art. The Percent for Art program has been

uniquely successful, adding the special creativity and aesthetics offered by an artist, while also upgrading the design standards of municipal construction projects. By the end of the Koch administration, over 40 projects were underway. Today, 202 projects have been completed throughout the city with 39 more in progress. It's delightful to see artwork that is part of sanitation facilities, schools, fire and police stations, and city parks. The city's program also influenced the MTA to apply the policy to all subway and commuter railroad projects.

The success of the program was aided by the New York City Art Commission, a body charged since 1898 with the responsibility of reviewing all art and construction proposed for city-owned prop-

In June, 1985, a 14-foot-high sculpture entitled *Growth*, by artist Jorge Luis Rodriguez, is unveiled in the East Harlem Art Park at 121st Street and Sylvan Place in Harlem. It was the first Percent for Art commission.
Courtesy of the New York City Art Commission

erties. The Art Commission became a much more influential body during the Koch administration, particularly under the leadership of Chief of Staff Diane M. Coffey, and its executive director from 1983 to 1990, Patricia E. Harris (now a deputy mayor under Mayor Bloomberg). It demanded that agencies pay more attention to design issues, and tightened its review process. It also undertook, with the Municipal Art Society, a major restoration project of WPA murals in city-owned buildings, and enhanced its archive of New York City public works.

Not Just Manhattan

Once capital dollars were again made available to the Parks Department, Commissioner Gordon Davis moved quickly to fix up neighborhood parks through a "Neighborhood Improvement Program." This initiative spread dollars to many parks and made a perceptible difference, all-important in the department's relations with borough presidents and the City Council. By 1983, the department's capital program had increased to $100 million.

Most important were the changes, starting in late 1979, in how parks were managed. It began with Central Park. After a year in which conditions got no better in the heart of Manhattan, Betsy

Barlow (now Betsy Barlow Rogers), was appointed first Central Park administrator. Ms. Barlow had been the head of a private group, the Central Park Task Force. She was given the responsibility of thinking through the needs of the Park, designing improvements, and overseeing their realization. Her operating authority was in fact limited, but she was positioned to exercise considerable moral persuasion.

Her initial command office was paid for by a private grant. After a year, the nascent private/public partnership was institutionalized with the creation of the Central Park Conservancy and the appointment of an influential board to back it. The Conservancy hired horticulturalists and landscape architects and privately funded its planning and design studies that offered a compelling vision for both public and private funding.

The first campaign to raise $50 million in private funds for Central Park was launched in 1985. In total, over $300 million has been raised from the private sector in the intervening years to transform Central Park into a superb urban open space.

The appointment of the Central Park administrator was followed quickly with similar appointments in Brooklyn and Queens, and the department was converted to a borough administrative structure. This structure remains today, with expanded authority granted to the conservancies for day-to-day management of the parks.

Private resources were brought into parks through the conservancies and through entities such as the Bryant Park Restoration Corporation that married the common interests of the New York Public Library and the park that lay behind the Research Library. The Central Park Conservancy and the Prospect Park Alliance, together with other public/private partnerships, today raise over $70 million annually for parks.

The department shed some of its load by leasing facilities, such as golf courses and ice skating rinks, to private operators. Management of the zoos was transferred to the New York Zoological Society (now the Wildlife Conservation Society).

Gordon Davis left the Parks Department in the fall of 1983. He was succeeded by Henry Stern, a

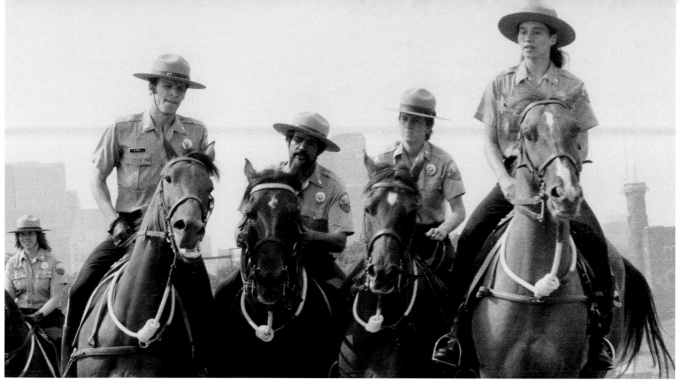

THE CALVARY
The Urban Park Rangers, launched in 1979 with $50,000 raised by Lewis Rudin, on patrol in January, 1980. These park employees mounted on horseback captured the public imagination and represented a new spirit in parks management.
William LaForce

former city councilman and lifetime New Yorker. Commissioner Stern was able to expand the City's open space under the department's jurisdiction by 1,250 acres, or 5 percent. He also pursued an aggressive tree protection and planting program. The Adopt-a-Monument program was established, and partnerships with the private community to improve park conditions were expanded.

The superb condition of Central Park in 2003 enabled Mayor Michael R. Bloomberg and his parks commissioner, Adrian Benepe, to say "yes" to The Gates Project, in contrast to Commissioner Davis' decision in 1981 that the Park was just too impaired to host the project and the many visitors it would attract.

On February 12, 2005, Christo and Jeanne-Claude unfurled 7,500 gates, with the assistance of their volunteers, for a dramatic 16-day public art celebration. The Gates' placement along 23 miles of pathways laid out long ago reflected the genius of Frederick Law Olmsted's design, particularly when viewed from on high. The public's response in coming out in the winter cold and snow to bask in the Gates' saffron color and to see the interplay of color, light, and shadow evoked the spirit of New Yorkers, their love of public art, and a great sense

of community. Indeed, perhaps no place else do New Yorkers share the goodwill of community today more than in our parks.

As one looks back at the 12 years, one sees a mayor who understood the central role of the arts and parks in the city, a mayor who gave his commissioners wide latitude to be innovative and manage their agencies, and a mayor who supported community partnerships for better governance, as well as private support. Much was accomplished in those 12 years, and patterns of governance and support established then remain today—all sustaining a better city.

Ronay Menschel was Deputy Mayor and Executive Administrator in the Koch administration from 1978–1982; one of her areas of responsibility was the arts. After leaving City Hall, she served as Chairman of the Commission for Cultural Affairs and was active in increasing arts education in public schools. Today, Ms. Menschel is a trustee of the Museum of the City of New York, the Public Art Fund, and Chairman of the Board of Phipps Houses, an affordable housing and community development organization.

COMING BACK
Signs of progress include the 1980 restoration of
the beloved Bethesda Fountain in Central Park.
John Pedin

STILL RELEVANT AT 80
BY HENRY STERN

In the 16 years since he left Gracie Mansion on December 31, 1989, Edward I. Koch has carved a remarkable role for himself in New York. He often said that if he was not reelected, he would get a better job, but the people would not get a better mayor.

Koch set out to prove his point, as a partner in the national law firm Bryan Cave, which merged with Robinson, Silverman—the New York firm he joined in 1990. His law office, decorated with pictures of world leaders, is a base from which, in addition to the firm's private practice, he engages in numerous activities such as speaking at events (for a fee), endorsing candidates, and making commercials for them, whether Democrats or Republicans.

He appears on a weekly cable television series, *Wise Guys*, with former senator Al D'Amato and former public advocate Mark Green. He acts as a source and reference for countless newspaper and magazine reporters, writes a weekly column which has been published, at different times, in the *Daily News*, the *Post* and *Newsday*, conducts a radio call-in show, for two years made decisions as Judge Wapner's successor on the *People's Court* TV series, endorses products (for a fee), and encourages young people to enter public service. Koch has traveled to Israel twice with Mayor Bloomberg, and he writes frequently on the Middle East and the threat of anti-Semitism around the world, while not hesitating to criticize the Israeli government when he disagrees with its policies.

He conducts a lively correspondence with public officials on a variety of issues, and mails his letters and the responses he receives to a list of several hundred people who have asked to receive them. His weekly column is sent by e-mail to thousands of free subscribers, and the list grows daily. Koch maintains his active interest in world and city affairs, reading five newspapers a day, which are delivered to his home very early each morning, before he goes to the gym and then to his law firm.

Koch is an adviser to some elected officials, and to many aspirants for office who come to see him. He is gracious with his time when new candidates seek him out, and he shares his views with them, even if he does not support them. Because he endorses candidates from both parties, his endorsement is more valuable, since voters know he is not simply following a party line

On top of that, he is a movie critic for the Greenwich Village weekly, *The Villager*. The Village is the neighborhood where he began his political career almost a half-century ago. Another local weekly which has grown enormously is *The Village Voice*. Koch was a close friend of editor Daniel Wolf and psychologist Edwin Fancher, two of the four men who founded the *Voice* in 1955. Norman Mailer was the third founder, and an investor the fourth.

Koch occasionally attends the theater, but his true passion is for films: he sees two or three a week. At a recent film, when his guest wanted to leave, he said, "I can't. I'm a critic."

He eats more than he should, but relies on vigorous cardiovascular exercise five mornings a week to keep in shape. His health history is lengthy, but he has shown great recuperative powers. His father, Louis Koch, lived to his late 80s. His mother died of cancer in her 60s.

What Koch has done is unique because the vast majority of former elected or appointed officials do not act as public persons once they leave office. They either devote themselves to earning a living in the private sector or they retire on the money they have amassed. They do not usually maintain their interest in the city or state, and they are generally not asked for their opinion by the media.

STRANGE BEDFELLOWS
In June, 2001, Koch marched with Representative Nydia Velasquez in support of Reverend Al Sharpton, who had been jailed for protesting the navy's bombing of the Puerto Rican island of Vieques.
Andrew Savulich

Ed keeps in touch with those who were part of his administration. Once a year, on or near his birthday, which is December 12th, his former commissioners and deputy mayors gather to celebrate the twelve years of his mayoralty, 1978–1989, and to renew relationships with each other. Usually, these gatherings, which are paid for by the guests, are held in a midtown hotel or catering hall, but last year, for the mayor's 80th birthday, the party was hosted by Mayor Bloomberg at Gracie Mansion.

Ten years previously, a smaller dinner party was held for Mayor Koch's 70th birthday by Mayor Giuliani. In the 1993 mayoral race, Koch had endorsed Giuliani, who had the backing of both Republican and Liberal parties, over the Democratic incumbent, Mayor David Dinkins. In 1989, he had supported Dinkins over Giuliani, and Dinkins won by two points. By 1993, Koch and about 50,000 other New Yorkers had switched in response to the Crown Heights riots, the boycott of the Korean grocer, and the second fiscal crisis requiring layoffs. Giuliani won by two points, with the help of commercials by Mayor Koch and the late deputy mayor and president of the Board of Education, Robert F. Wagner Jr. (1944–1993). The next year, Koch broke with Giuliani because he appointed judges not approved by an impartial screening panel, whose recommendations Koch had always followed. Although the two mayors did not reconcile, Koch supported Giuliani for reelection in 1997 when he was challenged by Manhattan's borough president Ruth Messinger, whom Koch liked even less. He also disagreed with many of her views, which he thought radical.

CROSSING OVER
Koch angered many Democrats by endorsing President George W. Bush in 2004 and speaking at the Republican National Convention in New York. Koch explained his support by saying Bush had a more effective approach to the war on terror than Democratic nominee John Kerry, and was a better friend to Israel.
Michael Appleton

In 2001, when term limits forced Giuliani to leave office, Koch strongly supported Michael Bloomberg over Public Advocate Mark Green, an official with whom he had differed for many years. Giuliani and Pataki also supported Bloomberg, who was a Democrat turned Republican so he could run for mayor. But it was Koch who crossed party lines to make his endorsement, just as he had done 36 years before when he endorsed John V. Lindsay for mayor on the day before the 1965 election.

His highest-profile endorsement came in 2004, when he supported the reelection of President Bush. Koch said that although he disagreed with Bush on all domestic matters, the president's strong stand against terrorism was, for him, the most important issue of the campaign. He held fast to this position despite criticism from fellow Democrats,

and campaigned for Bush in Florida and Ohio. It was the only time in his life that he supported a Republican for president. He prefers Hillary Clinton for 2008.

Unpredictability and independence have been characteristic of Mayor Koch through his political career, and these qualities have endeared him to New Yorkers even when they disagreed with him. People still remember specific events, like his standing up to the transit union and urging New Yorkers to walk across the Brooklyn Bridge. He watches the world go by, but continues to take an active part in it.

His current ambition is expressed in the title of a book he wrote, *Remaining Relevant* (William Morrow & Company, 2000). It is a wish that he has, so far, achieved handsomely. In this endeavor, he

BIG SUPPORTER
Koch is greeted by Mayor Bloomberg as an honored guest at the State of the City speech in January, 2004.
Andrew Savulich

has been a conspicuous success, unparalleled by other former local elected officials. His recognition on the street remains very high, and most people say very nice things about his work as mayor. When people are hostile, he replies in kind.

Perhaps the reason for this unique afterlife is Koch's continued ebullience and energy. It may be that he visibly represents the spirit of New Yorkers.

Years ago, Clay Felker, then editor of *New York* magazine, referred to Koch as the "quintessential New Yorker." Felker is now a Californian, but Ed Koch will always be a New Yorker.

VIP CROWD
Top: Koch marches in the 2003 Saint Patrick's Day parade with ex-mayor Rudy Giuliani and Governor George Pataki.
Susan Watts

Bottom: Koch chows down at the US Open tennis championship in September, 2003 with former mayor David Dinkins and Mayor Bloomberg.
Mike Albans

Henry J. Stern was a City Councilman at Large (Lib-Man) from 1974 to 1983. He left the council when Mayor Koch appointed him Commissioner of Parks & Recreation, a position in which he served for seven years. In 1994, Mayor Giuliani brought him back to Parks for eight years as Commissioner. In 2002, he founded New York Civic, and has since written hundreds of articles on civic affairs.

Andrew Savulich

INDEX

Michael Lipack

NEW YORK COMES BACK
The Mayoralty of Edward I. Koch

Published in the United States by powerHouse Books,
a division of powerHouse Cultural Entertainment, Inc.
68 Charlton Street, New York, NY 10014-4601
telephone 212 604 9074, fax 212 366 5247
e-mail: koch@powerHouseBooks.com
website: www.powerHouseBooks.com

First edition, 2005

Library of Congress Cataloging-in-Publication Data:

New York comes back : the mayoralty of Edward I. Koch / edited by Michael Goodwin ;
 texts by Pete Hamill ... [et al.] ; in association with the Museum of the City of New
 York.-- 1st ed.
 p. cm.
 ISBN 1-57687-274-2 (pbk.)
 1. Koch, Ed, 1924- 2. Koch, Ed, 1924---Pictorial works. 3. Mayors--New York
(State)--New York--Biography. 4. New York (N.Y.)--Politics and government--1951- 5.
New York (N.Y.)--Social policy. I. Goodwin, Michael, 1949- II. Hamill, Pete, 1935- III.
Museum of the City of New York.

F128.54.K63N49 2005
974.7'1043'092--dc21
[B]

 2005049258

Paperback ISBN 1-57687-274-2

Separations, printing, and binding by Lotus Printing, Inc.

Book design by Kiki Bauer

A complete catalog of powerHouse Books and Limited Editions is available upon request; please call, write, or tell us how we're doing on our website.

10 9 8 7 6 5 4 3 2 1

Printed and bound in Hong Kong

Front cover: Photograph by Vincent Riehl
Back cover: Photograph by Susan Watts

The Daily News would like to acknowledge Patrick Montero, Tamara Codor, Rita Robinson, Stu Horvath, and Ann Marie Linden.